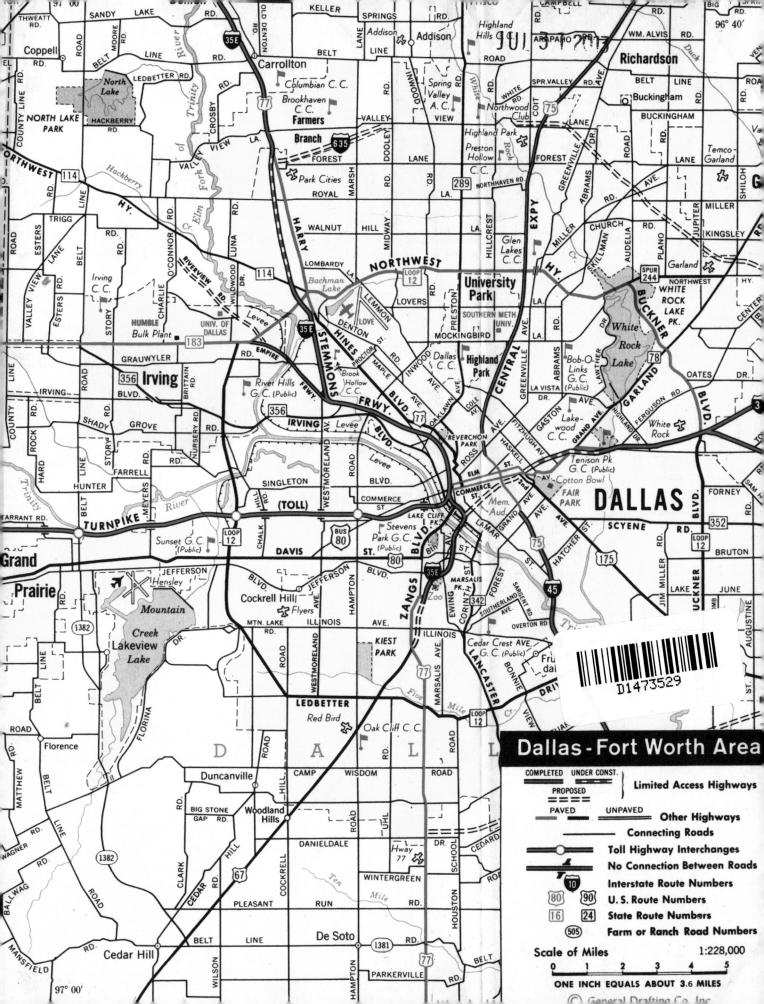

Dallas-Fort Worth Area

DALLAS

Richardson

Irving

Grand Prairie

Legend:

COMPLETED	UNDER CONST.	
		Limited Access Highways
PROPOSED		
PAVED	UNPAVED	**Other Highways**
		Connecting Roads
		Toll Highway Interchanges
		No Connection Between Roads
10		**Interstate Route Numbers**
80	90	**U. S. Route Numbers**
16	24	**State Route Numbers**
505		**Farm or Ranch Road Numbers**

Scale of Miles 1:228,000

0 1 2 3 4 5

ONE INCH EQUALS ABOUT 3.6 MILES

© General Drafting Co. Inc.

D1473529

Hotel Texas

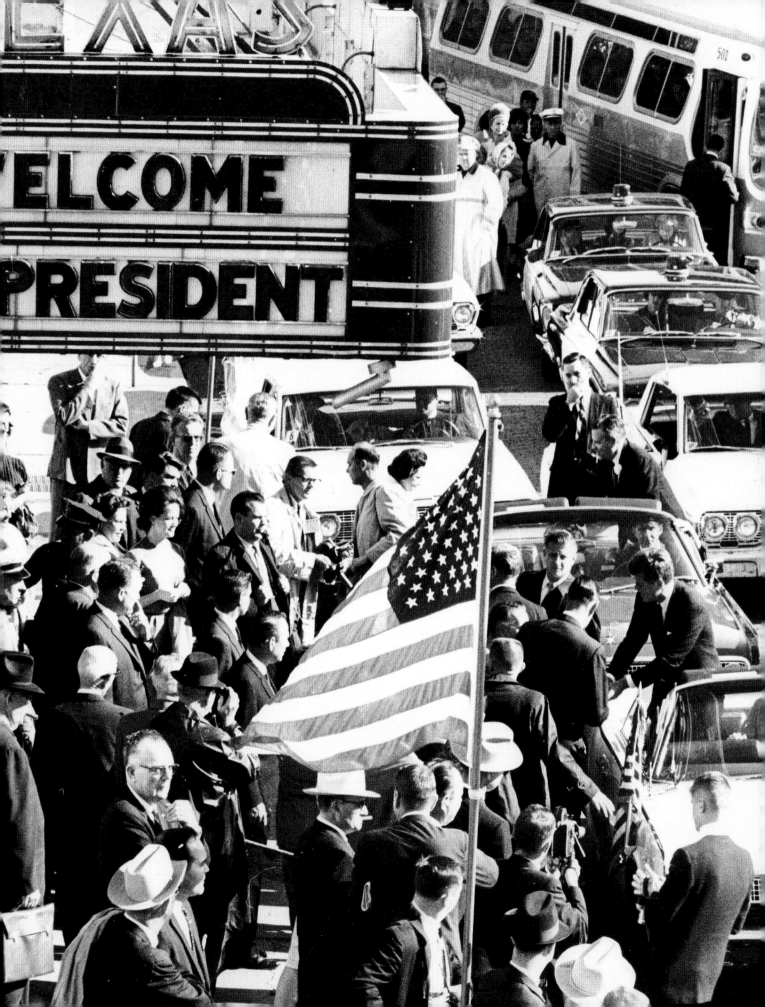

Dallas Museum of Art

Amon Carter Museum of American Art, Fort Worth

Distributed by Yale University Press, New Haven and London

HOTEL TEXAS

An Art Exhibition for the President and Mrs. John F. Kennedy

Essays by Olivier Meslay, Scott Grant Barker, David M. Lubin, and Alexander Nemerov
Chronology by Nicola Longford

Lenders to the Exhibition

Katherine Elizabeth Albritton

Amon Carter Museum of American Art, Fort Worth, Texas

Modern Art Museum of Fort Worth, Texas

Gwendolyn Weiner with three loans courtesy of the
 Palm Springs Art Museum, California

And several lenders who wish to remain anonymous

For loans of ephemera:
 Scott Grant Barker
 Gregory Dow
 Douglas Harman
 The Sixth Floor Museum at Dealey Plaza, Dallas

For Ruth Carter Stevenson

1923–2013

Contents

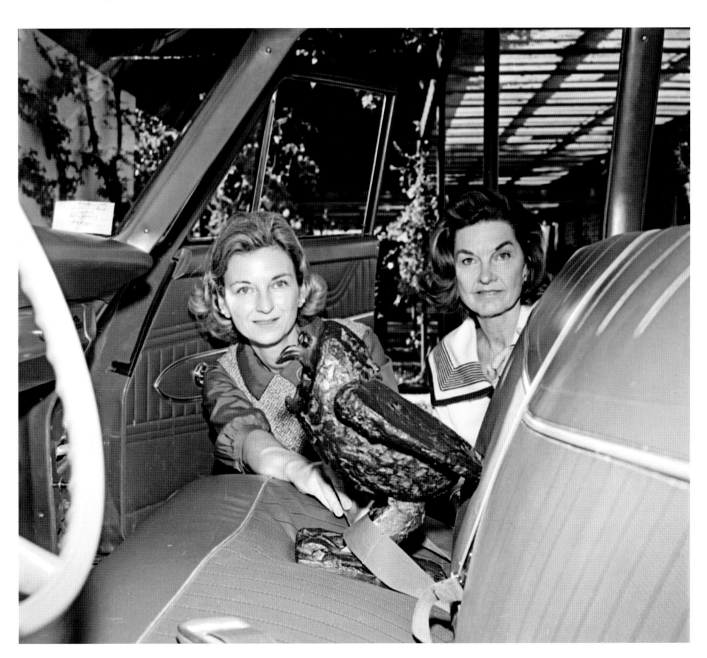

Foreword

Amid the political and historical analyses bearing upon the fiftieth anniversary of President John F. Kennedy's assassination, the story of a small art exhibition assembled for the president and Mrs. Kennedy at Hotel Texas in Fort Worth for their overnight stay on November 21, 1963, constitutes a rare intersection between art and historical tragedy.

Hotel Texas: An Art Exhibition for the President and Mrs. John F. Kennedy is a moving story, a tribute to the Kennedys' interest in art, and a fascinating opportunity to look from a different perspective at his fatal visit to Texas. It is fitting that the Dallas Museum of Art and the Amon Carter Museum of American Art in Fort Worth, as representatives of their respective sister cities, should collaborate to present this exhibition and publish the accompanying catalogue. Since 1963 the citizens of the Metroplex have lived under the dark cloud of this traumatic event, in which a collective innocence was lost forever. *Hotel Texas: An Art Exhibition for the President and Mrs. John F. Kennedy* presents a life-affirming counterpoint to painful memories and stigma.

This exhibition reunites the magnificent artworks assembled at that time. It is an unusual task to pay tribute to and thank those who organized an exhibition fifty years ago, and those who are reenacting it half a century later. The first one was organized at the suggestion of Owen Day, with the dedication and guidance of Ruth Carter Johnson (later Stevenson) and Sam B. Cantey III. It comprised loans from Stevenson and Cantey and from Mr. and Mrs. Perry Bass, Mr. and Mrs. William M. Fuller, Mr. and Mrs. Ted Weiner, the Amon Carter Museum of Western Art (now the Amon Carter Museum of American Art), and the Fort Worth Art Association, which today still governs the Modern Art Museum of Fort Worth. Mitchell Wilder, the director of the Amon Carter, and his facilities superintendent, E. B. Brown, installed the exhibition in suite 850. Gertie Rapp and John Schoolcraft at the First National Bank of Fort Worth provided exhibition catalogues. Hotel Texas staff members Iva Estes, A. D. Rials, and B. B. Stroud oversaw other aspects of the exacting preparation of the rooms. Present-day links to this period and these people were provided by Kerri Holloway,

Morris Matson, Mr. and Mrs. Stuart Monroe, Bob Ray Sanders, and Tiffany Schureman, and we are grateful for their help. Special thanks are owed to the late Mary Alice Bohle, who kept safe the memory of this unique exhibition and freely shared it.

We offer our particular appreciation to Olivier Meslay, Associate Director of Curatorial Affairs, Senior Curator of European and American Art, and The Barbara Thomas Lemmon Curator of European Art at the Dallas Museum of Art, for having conceived of and organized the exhibition and its accompanying publication. His vision and persistence have been instrumental in shaping the commemoration in Dallas. On his behalf, we wish to acknowledge the role of the Chairman of the Board of Trustees of the Dallas Museum of Art, Deedie Rose, who after a long and decisive conversation with Olivier gave the entire project its initial, and critical, momentum. We also wish to acknowledge the insights and assistance of the historian Scott Grant Barker, who researched the original exhibition and contributed a vivid essay narrating the way in which the best of human intentions and the setting of a Fort Worth hotel suite produced a bittersweet farewell to the nation's thirty-fifth president; David Lubin, Charlotte C. Weber Professor of Art at Wake Forest University, who, in his provocative essay, explores the symbolic connotations of the impromptu art exhibition against a backdrop of wider cultural stereotypes; Alexander Nemerov, Carl and Marilynn Thoma Provostial Professor in the Arts and Humanities at Stanford University, whose essay on the presence of Thomas Eakins's *Swimming* in the Kennedy suite explores the power of pictures to gather, contain, and express the experiences of those who see them; and Nicola Longford, director of the Sixth Floor Museum in Dallas, who wrote the catalogue's illustrated chronology. We would also like to recognize the Sixth Floor Museum for assisting us on every level. We thank Scott Barker, Gregory Dow, and Doug Harman, who generously shared memorabilia and rare archival material for this project.

A project of this nature can never achieve its full potential without the inspired support of numerous committed individuals. We would like to offer our sincere thanks to those at

the Amon Carter Museum of American Art who helped in the realization of this exhibition and book: Marci Caslin, Registrar; Margi Conrads, Deputy Director of Art and Research; Lori Eklund, Senior Deputy Director; Jonathan Frembling, Archivist and Reference Services Manager; Will Gillham, Director of Publications; Stefanie Ball Piwetz, Publications Manager; Shirley Reece-Hughes, Assistant Curator of Paintings and Sculpture; and Steven Watson, Senior Photographer. Likewise, the following staff at the Dallas Museum of Art were critical in bringing this project to fruition: Jill Bernstein, Director of Public Relations; Giselle Castro-Brightenburg, Imaging Manager; Elizabeth Donnelly, Exhibitions Assistant; Jessica Harden, Director of Exhibition Design; Martha MacLeod, Curatorial Administrative Assistant; Andrew Sears, former McDermott Curatorial Intern; Gabriela Truly, Director of Collections Management; Joni Wilson, Exhibitions Manager; Tamara Wootton-Bonner, Associate Director of Collections and Exhibitions; and Eric Zeidler, Publications Manager.

We also offer our great thanks to Amanda Freymann and Joan Sommers of Glue + Paper Workshop LLC, for their inspired design and for overseeing production of the catalogue; to Frances Bowles for her meticulous editing of the text; to Sharon Vonasch for her careful proofreading; and to Patricia Fidler, Lindsay Toland, and the publicity department at Yale University Press, our partner and distributor.

Major support for this exhibition and catalogue comes from Citi Private Bank and American Airlines in Dallas, and from Shirlee J. and Taylor Gandy, in memory of Ruth Carter Stevenson, in Fort Worth. These underwriters have allowed our joint undertaking to be developed and perfected on the level that such a riveting subject requires.

Finally, we would like to extend our sincere gratitude to the lenders for the 2013 re-creation of the exhibition: Katherine Albritton, the Amon Carter Museum of American Art, the Modern Art Museum of Fort Worth, Gwendolyn Weiner and Steve Nash, the Director of the Palm Springs Art Museum, who helped facilitate three of Ms. Weiner's loans, and several lenders who wish to remain anonymous.

It is our hope that this exhibition and catalogue, coinciding with the fiftieth anniversary of a national tragedy, encapsulate something both permanent and uplifting in the face of an increasingly strident and harried mass culture in the early twenty-first century. *Hotel Texas: An Art Exhibition for the President and Mrs. John F. Kennedy* reminds us that there is always more to a tragedy than the headlines.

Maxwell L. Anderson
The Eugene McDermott Director
Dallas Museum of Art

Andrew J. Walker
Director
Amon Carter Museum of American Art

Dallas and Fort Worth, 2013

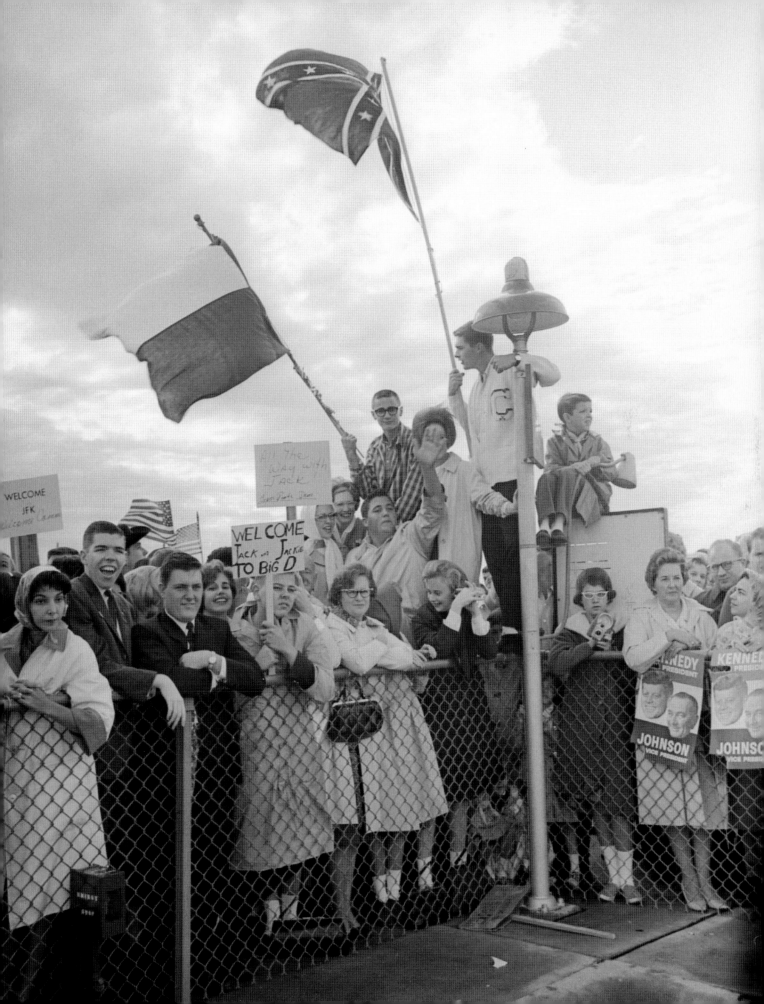

"Art Is Not a Form of Propaganda; It Is a Form of Truth"

Olivier Meslay

We must never forget that art is not a form of propaganda; it is a form of truth.... In free society art is not a weapon and it does not belong to the spheres of polemic and ideology. Artists are not engineers of the soul. It may be different elsewhere. But democratic society—in it, the highest duty of the writer, the composer, the artist is to remain true to himself and to let the chips fall where they may. In serving his vision of the truth, the artist best serves his nation. And the nation which disdains the mission of art invites the fate of Robert Frost's hired man, the fate of having "nothing to look backward to with pride, and nothing to look forward to with hope."

—President John F. Kennedy, Amherst College, October 26, 1963

It was perhaps this speech, or at least its central theme, that gave the citizens of Fort Worth the idea of preparing an art exhibition for President John F. Kennedy and his wife, Jacqueline, who spent their last night together among the objects thus assembled. During his New Frontier campaign, Kennedy had featured art significantly in his political discourse: "And the New Frontier, for which I campaign in public life, can also be a New Frontier for American art."[1] A year later, in a letter to Leonard Bernstein, the president wrote: "I am hopeful that this collaboration between government and the arts will continue and prosper. Mrs. Kennedy and I would be particularly interested in any suggestions you may have in the future about possible contributions the national government might make to the arts in America."[2] One of the most beautiful manifestations of this continuing interest was the concert given by the great cellist Pablo Casals on November 13, 1961, at the White House. It was a striking demonstration of the young couple's interest in the arts and their ability to attract the most principled artists (fig. 1).

The president and his wife were not alone in recognizing the importance of art as a component of national policy and global influence. For the first time in the history of the United States, Americans were aware that their national art had acquired universal value and that the artists on the American scene—abstract expressionists, pop and, later, minimalist artists—were, whatever people thought of them at home, the great artistic beacons of their time.[3] This awareness came at a time of sustained debate about the new art forms and the reactions they sometimes elicited from an artistic tradition primarily defined by American values. The newcomers were so much in favor of modernity and openness to the world that they did not always realize how much their art, seemingly so free of tradition and vaunting its international credentials, owed to the American space, the American city, and a modernity that was itself very American.

These aesthetic debates were often interwoven with the violent polemics of the McCarthy era. In Dallas, for example, there was vocal hostility in 1955 and 1956 to the exhibition of works by Picasso, even though the Dallas Museum of Art had shown Jackson Pollock's *Cathedral* (fig. 2) on its walls since 1950. The controversy long divided the city and the Museum and, in 1957, resulted in a split in the institution, with the creation of the Dallas Museum for Contemporary Arts. Although partly driven by fear of censorship, the split was also a response to the need for a nimbler attitude vis-à-vis the changing international contemporary art scene. The wounds that this division caused were healed only in

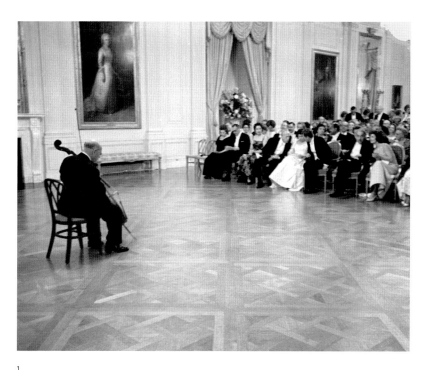

1

Recital by Pablo Casals, at a
State Dinner for Governor Luis
Muñoz Marín of Puerto Rico, the
White House, Washington, D.C.,
November 13, 1961

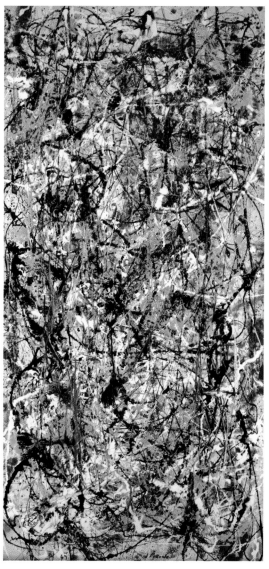

2

Jackson Pollock, *Cathedral,* 1947.
Enamel and aluminum paint on
canvas, 71½ × 35 inches. Dallas
Museum of Art, gift of Mr. and
Mrs. Bernard J. Reis, 1950.87

April 1963, when the two museums merged again, a few months before the president's visit.

These tensions were undoubtedly reflected in the selection of art for suite 850 in the Hotel Texas in Fort Worth. It was a manifesto in all but name to place Picasso's *Angry Owl* cheek-by-jowl with a canvas by Claude Monet and, as David Lubin points out in these pages, it was also a sign of the enduring rivalry between Fort Worth and Dallas. But there was more going on with the exhibition than the spirited contention between the metropolitan poles of Fort Worth and Dallas. Imagined by Owen Day, the exhibition of works selected by Ruth Carter Johnson (later Stevenson) and others with no other motive than to please and surprise the Kennedys, bridged the connection between nineteenth-century art and the most modern art of the day. Mrs. Stevenson famously delivered Picasso's *Angry Owl* to the Hotel Texas in the front seat of her car. It is with this background in mind that I felt it would be interesting to reconstitute the exhibition, the idea of which has acquired particular poignancy from the death of its principal inspiration and visitor. But it also seemed important to do so in order to include it among the commemorations of the fiftieth anniversary of the assassination of President Kennedy.

From close at hand, however, things look a little different. Dallas's perspective on the commemoration of the tragedy has long been distorted by the fear of reliving the past. When I arrived in 2009 as a stranger both to Dallas and the United States, this malaise was not immediately perceptible. But the deepest traumas are often the most secret, and this invisible fear was nonetheless a very real one. One tends to forget that such traumas do not affect the town in the abstract, but do affect each of its inhabitants individually. I remember visiting Claude Albritton, the man who, in 2009, first told me about this exhibition at the Hotel Texas. Throughout his youth, he told me, everywhere else in the United States—and indeed all over the world—the sight of the word *Dallas* on his passport or papers immediately elicited derogatory remarks. Many other Dallasites have shared similar experiences with me. Strangely enough, those most inclined to denial were often those who had invested the greatest hopes in the president's visit, or those who had been the most devastated by his assassination. There are many cities in the world that, in spite of their best efforts, retain the painful memory and, above all, the negative image of an event that took place within their boundaries. The hearts of their citizens seem to beat

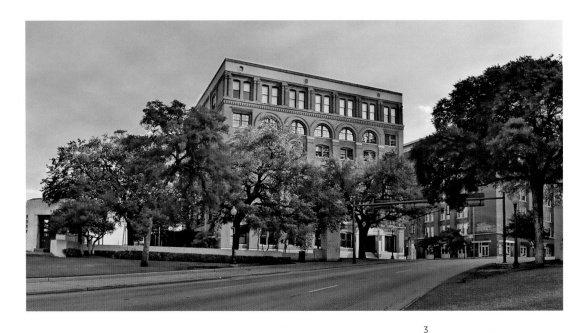

3

Photograph of the Sixth Floor
Museum, Texas School Book
Depository, Dallas

in a different way. It would be interesting to study their history and the means they have used to deliver themselves from ignominy. Some cities have escaped stigmatization even though they have witnessed similar dramas: cities such as Washington, D.C., where two presidents, Abraham Lincoln and James A. Garfield, were assassinated; or Buffalo, where William McKinley was mortally wounded. Only a few years separated the assassination of President Kennedy from that of his brother in Los Angeles and of Martin Luther King Jr. in Memphis. Neither city seems to have felt stigmatized by those tragedies. In Los Angeles, after clashes that are almost entirely forgotten today, the very scene of that assassination has been demolished and swept away. Conversely, Dallas has established the Sixth Floor Museum in the old Texas School Book Depository (fig. 3), from which the fateful shots of November 22, 1963, were fired. With a mixture of preexisting

energy, pride, an inferiority complex, denial, and collective guilt, Dallas stoically submitted itself to accept the condemnation of the world, never complaining about the stigmatization, but also never speaking about it.

Glenn Lowry, the director of New York's Museum of Modern Art, and I had a long discussion about how the anniversary of the Kennedy assassination should be approached; he reminded me of the violence that prevailed throughout the so-called Free World during this period—in the United States, France, Italy, Germany, Argentina, and Chile. Until the end of the 1970s, violence was omnipresent, in thought and in reality. Political assassinations were not only common currency but also seemed to form part of the natural landscape of political struggle. The barriers between verbal and physical violence were slender. The horrors of the Second World War were still present in people's minds, the Cold

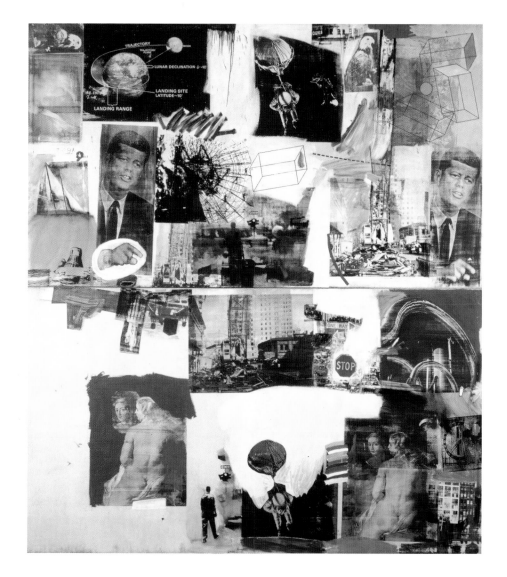

4

Robert Rauschenberg, *Skyway,*
1964. Oil and silkscreen on
canvas, 216 × 192 inches. Dallas
Museum of Art, The Roberta
Coke Camp Fund, The 500 Inc.,
Mr. and Mrs. Mark Shepherd Jr.,
and General Acquisitions Fund,
1986.8.A-B

War was at its peak, and, either because mindsets evolved too slowly or because it was the nature of the political doctrines to which the twentieth century had given rise, murder was considered a method like any other, and many deemed it justifiable. Moreover, the Kennedy assassination seemed to mark the beginning of the volatile period known as the Sixties, the break between an era of apparent consensus in the United States and one of radical gestures and deeds.

The Role of an Exhibition

What role can an exhibition play in the commemoration of an event of this magnitude? A great deal of discussion has taken place within the Dallas Museum of Art in the hope of finding, in an institution dedicated to the arts, the most appropriate way to commemorate one of the most tragic events in American history. There was strong support for an initial idea, that of bringing together an ensemble of art inspired by President Kennedy, from the works of Robert Rauschenberg—first and foremost *Skyway* (fig. 4), painted in memory of Kennedy and already in the collection of the Dallas Museum of Art—to those of Andy Warhol (to cite only the most famous names). We also conceived of an exhibition of works on the more general theme of assassination and political violence from Jacques-Louis David's *Death of Marat* (1793) to Edouard Manet's *Execution of Emperor Maximilian* (1868–69) or Gerhard Richter's *Tote 667.3* from the series October 18, 1977 (1988). Such discussions, particularly those with Jeffrey Grove, Hoffman Family Senior Curator of Contemporary Art, were deeply enriching. Ultimately the breadth of the subject, the difficulty of treating it delicately but powerfully, and the prevailing uncertainty about the nature of the commemorations in Dallas led us to decide on a more confined and concentrated vision. Finally, during a decisive impromptu discussion, the encouragement given by the Chair of the Board, Deedie Rose, convinced us that we were bound to take part in this sad commemoration.

At this point another question arose: why re-enact an exhibition at the Dallas Museum of Art that is original to Fort Worth?

The simplest response is that the idea of this commemorative exhibition was born and developed in Dallas. The more complex response resides in the inextricable link that exists between the two cities specific to that fateful day in November: Kennedy's last night was spent in the westernmost town; his last day ended thirty miles to the east. This shared legacy would not exist but for the catastrophe that unfolded during this twenty-four-hour slice in time—the Fort Worth exhibition would otherwise have dissolved into history, and Dallas would have been just another city on the president's itinerary through the state. Thus, a partnership was forged in 2012 between the Dallas Museum of Art and the Amon Carter Museum of American Art in Fort Worth. I should point out that, without the support of Andrew J. Walker, the director of the Amon Carter, nothing of this kind would have been possible. The two institutions, the Dallas Museum of Art and the Amon Carter, are the principal actors in this exhibition, and it is through their seamless collaboration that the project has been realized. Let us also gratefully acknowledge that irreplaceable link between the past and present, the woman who was behind the original exhibition at the Hotel Texas, Ruth Carter Stevenson, former president of Amon Carter's Board of Directors and daughter of Amon Carter, himself a proud champion of Fort Worth.

Other reasons as well led to this choice. For those who have not lived much of their lives in the Metroplex, the division between the two cities seems clearly artificial and strangely evocative of Berlin after the fall of the Iron Curtain, or Buda and Pest before Budapest. The distance between the two cities is now so small that one is surprised to find that the president made the trip by plane. Today we can only imagine the strange voyage that took him from Carswell Air Force Base in Fort Worth to Love Field in Dallas, a flight of thirty miles and less than thirteen minutes.

Finally, to remember what took place at the Hotel Texas is also to restore the memory of a Texas welcome that has been obscured by the assassination. The murder of the president left a brutal image of both Dallas and Texas. But we must remember another aspect of President Kennedy's trip: crowds of people

5

John F. Kennedy reaching out to the crowd, Fort Worth, November 22, 1963

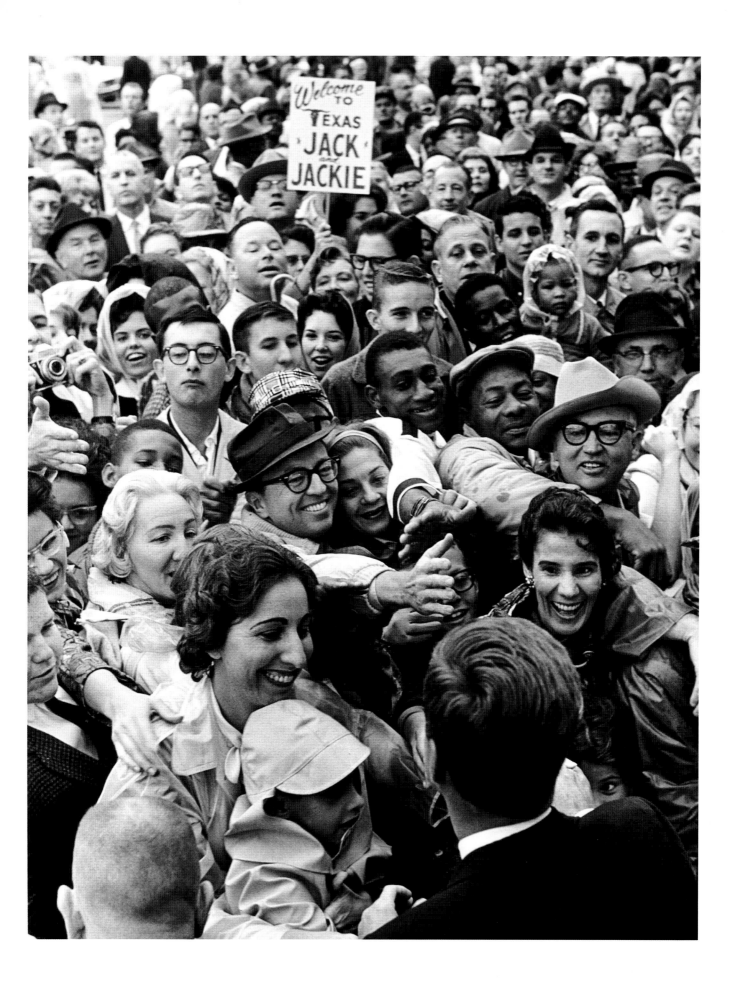

were overjoyed by it, and vast numbers assembled to acclaim him (figs. 5 and 6), both in Fort Worth and in Dallas. There are many still alive today who were waiting in the hall at which the lunch in his honor was to be held. What strikes one today is the enthusiasm that they manifested and the stupor and terror almost universally felt when his assassination was announced.

Dallas has spent nearly fifty years in the shadow of this obsession without always realizing that these tragic events forced it to radically reinvent itself. Without ever consciously accepting the fact, without ever speaking of it so as not to be seen as complaining, but with the idea of overcoming this trauma and surviving the resulting stigma by which it became known to the world as the city of JFK's death, Dallas has created a landscape wholly different from that of 1963. Fifty years on, part of what is great about Dallas comes from sublimating this tragedy. In the aftermath of the assassination, the city leaders, in a sort of hairpin turn from former politics, asked one of the founders of Texas Instruments, Inc., J. Erik Jonsson, to take over the city as mayor. He was an easterner, an engineer, and a businessman. In 1965 he established a program called Goals for Dallas that asked the question, "What kind of city do you want to be?" The program initially solicited ideas from some two dozen people (civic and religious leaders but also art and health professionals), expanding by 1969 into a far-reaching venture seeking input from thousands of people. He reshaped the city not only physically but also psychologically. Later Jonsson recalled: "They needed something to do, to talk about, and to work with that was as far apart from the assassination and its grieving as it could possibly be. I think that we were fortunate to hit on this, and we took full advantage of it."[4]

We should remember what certain artists—Sandro Botticelli, Leonardo da Vinci, or (more methodically if with less renown) Alexander Cozens—have written about the metamorphosis of a stain into a wonderful new landscape. To pay homage to the deceased president by invoking the highest manifestations of human genius—those by which he was surrounded during his last night on earth—is to remember what was best about those times without denying what was ignoble or ever ceasing to remember the tragic destiny of one man.

1 Senator John F. Kennedy to Miss Theodate Johnson, September 13, 1960, *Musical America* (October 11, 1963), 11.

2 President John F. Kennedy to Leonard Bernstein, September 8, 1961; Leonard Bernstein Collection, Music Division, Library of Congress (072.00.00).

3 Further reading on the subject includes versions of the events recorded in Serge Guilbaut, *How New York Stole the Idea of Modern Art: Abstract Expressionism, Freedom, and the Cold War*, trans. Arthur Goldhammer (Chicago: University of Chicago Press, 1983); Frances Stonor Saunders, *Who Paid the Piper? The CIA and the Cultural Cold War* (London: Granta Books, 1999); and Michael Kimmelman, "Revisiting the Revisionists: The Modern, Its Critics, and the Cold War," in *The Museum of Modern Art at Mid-Century: At Home and Abroad*, Studies in Modern Art 4 (New York: Museum of Modern Art, 1994), 38–55.

4 J. Erik Jonsson, quoted in http://www.ti.com/corp/docs/company/history/timeline/community/1960/docs/65-goals_for_dallas.htm.

In addition to those already mentioned, I would like to thank the following people who helped me understand the period and improve this introduction: Bill Jordan, Natalee and George Lee, James Traub, and in lasting gratitude and admiration, Margaret McDermott.

6
The President and Mrs. John F. Kennedy arriving at Love Field, Dallas, November 22, 1963

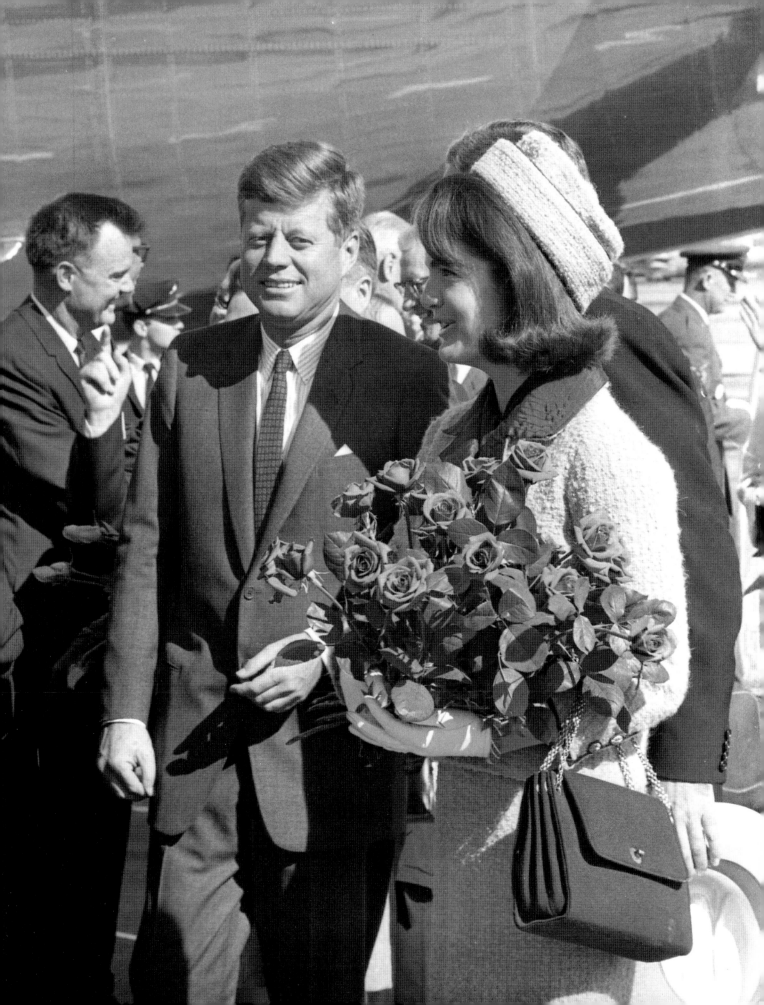

An Art Exhibition for the President and Mrs. John F. Kennedy

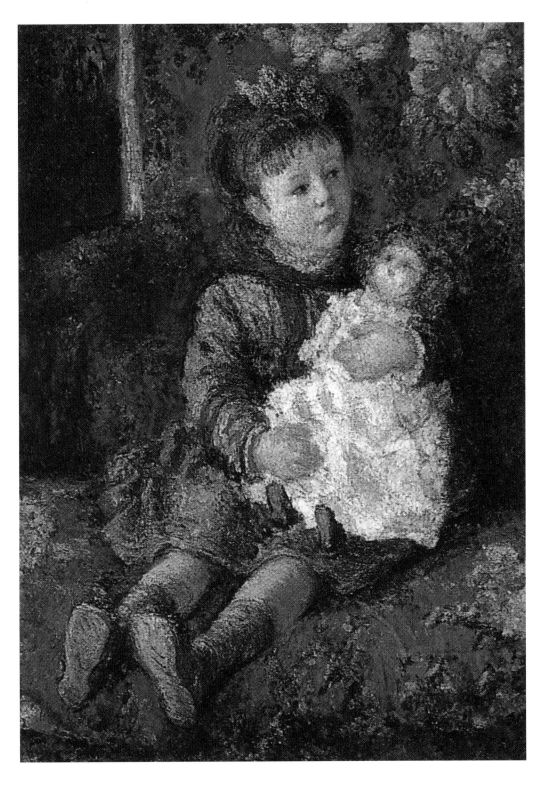

Plate 1
Claude Monet (1840–1926)
Portrait of the Artist's Granddaughter
(*Portrait de Germaine Hoschedé avec*
sa poupée), c. 1876–77
Oil on canvas
Location unknown

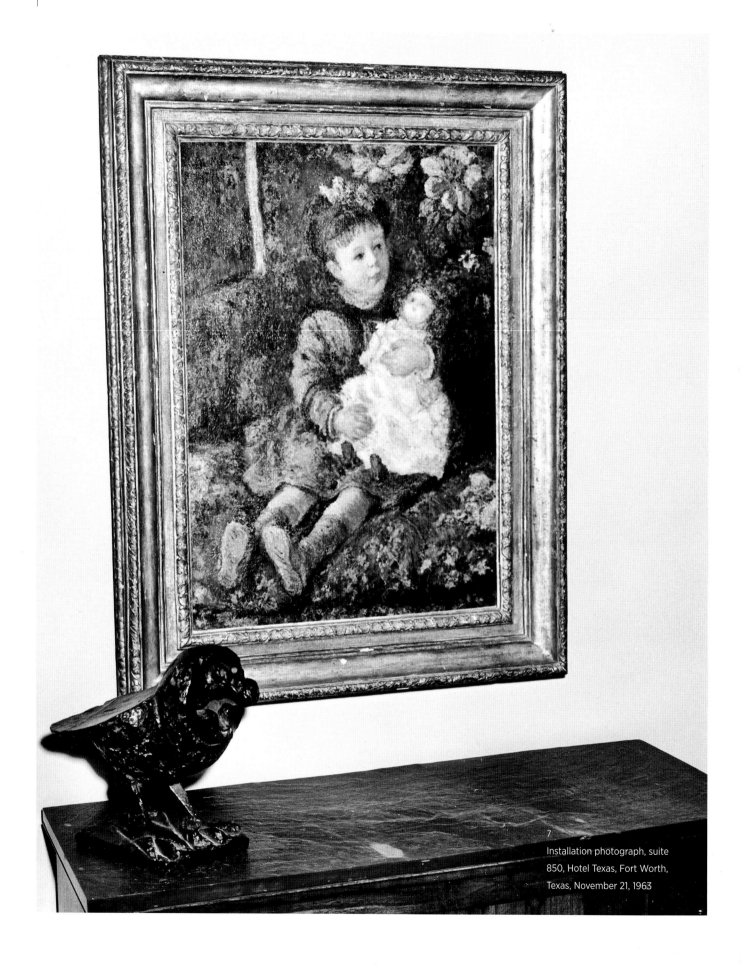

7

Installation photograph, suite 850, Hotel Texas, Fort Worth, Texas, November 21, 1963

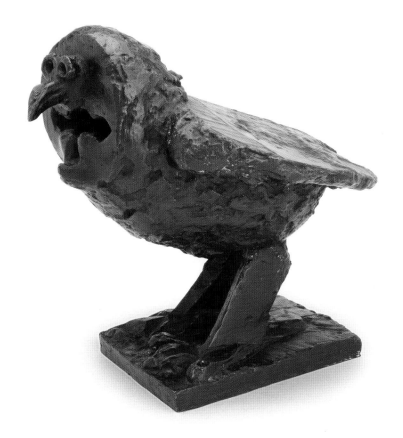

Plate 2
Pablo Picasso (1881–1973)
Angry Owl, 1951–53
Bronze
Collection of Gwendolyn Weiner

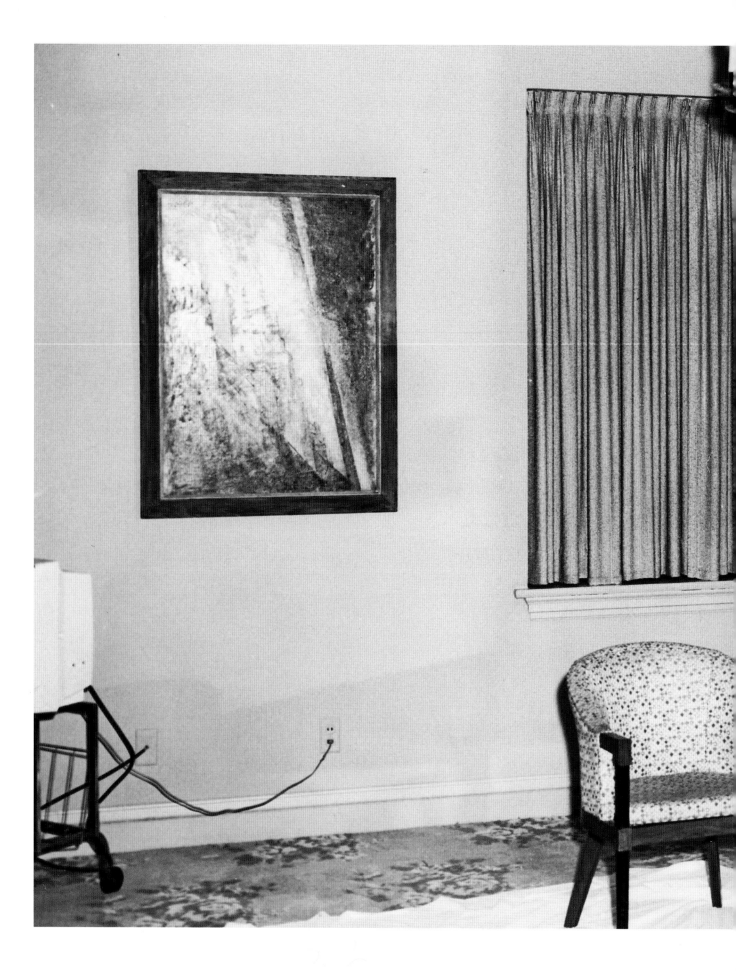

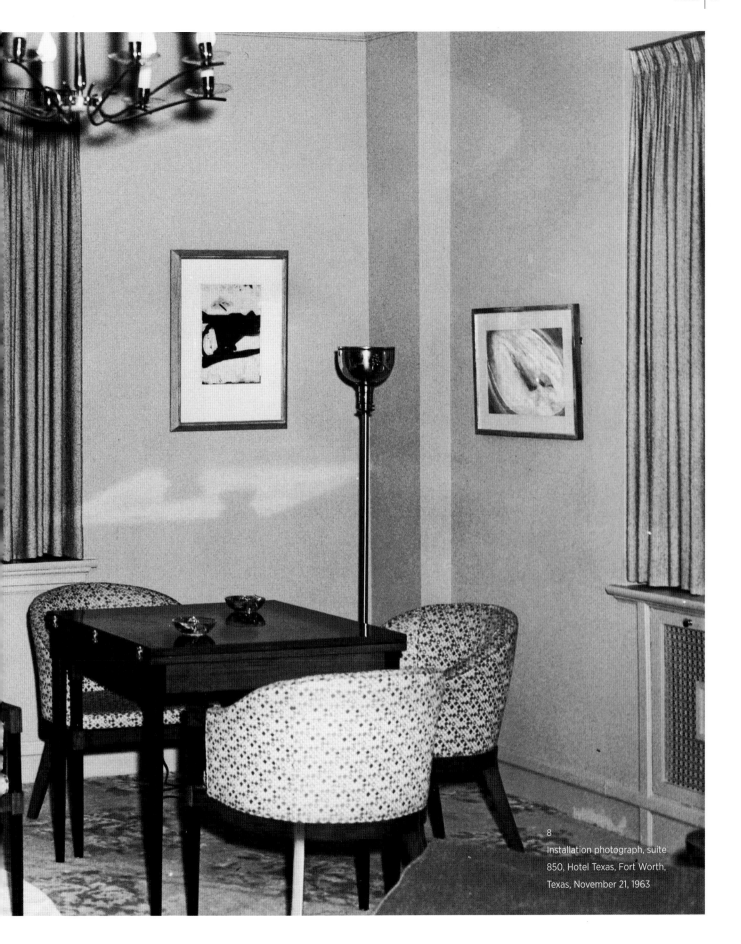

8
Installation photograph, suite
850, Hotel Texas, Fort Worth,
Texas, November 21, 1963

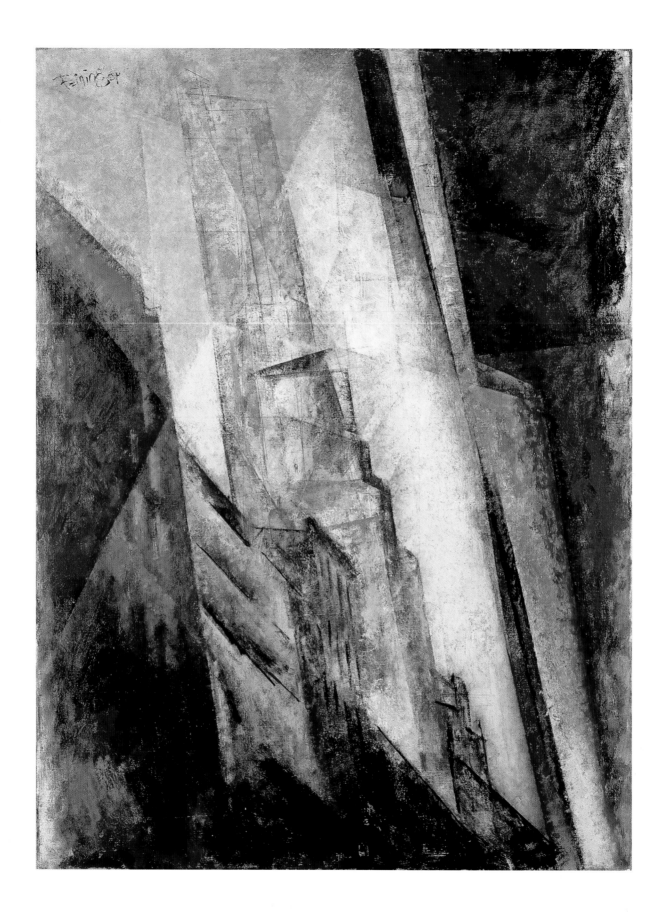

Plate 3
Lyonel Feininger (1871–1956)
Manhattan II, 1940
Oil on canvas
Modern Art Museum of Fort Worth,
Texas, anonymous gift. 1946.06.G.P.

Plate 4
Morris Graves (1910–2001)
Spirit Bird, c. 1956
Tempera on paper
Modern Art Museum of Fort Worth,
Texas, gift of the William E. Scott
Foundation. 1963.07.03.G.P.

Plate 5
Franz Kline (1910–1962)
Study for Accent Grave, 1954
Oil wash on paper
Extended loan to the Palm Springs
Art Museum, California, from the
collection of Gwendolyn Weiner.
L1980-4.10

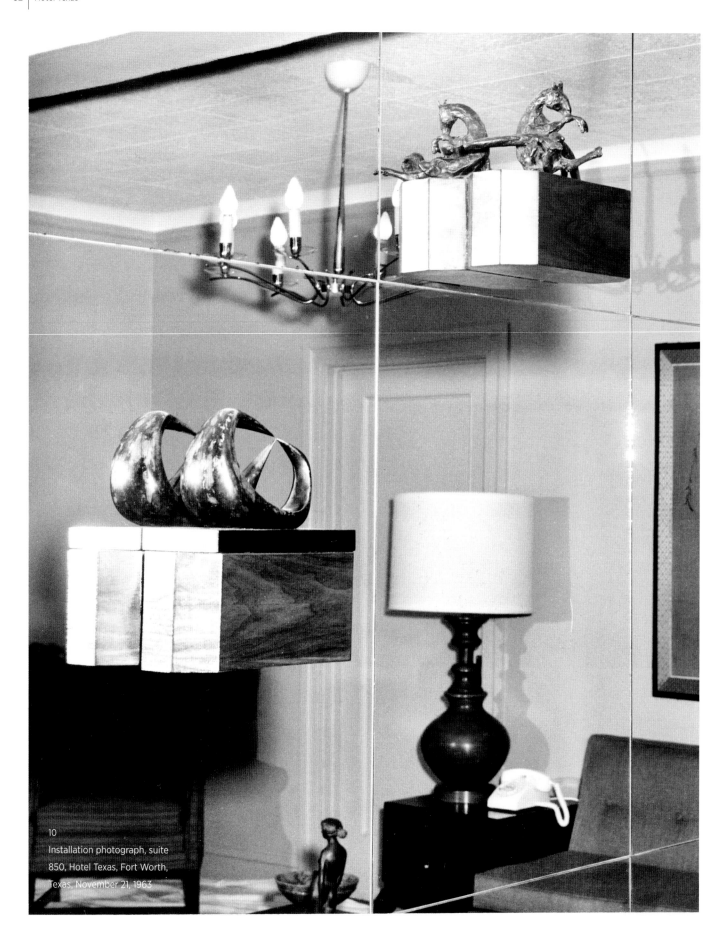

10
Installation photograph, suite
850, Hotel Texas, Fort Worth,
Texas, November 21, 1963

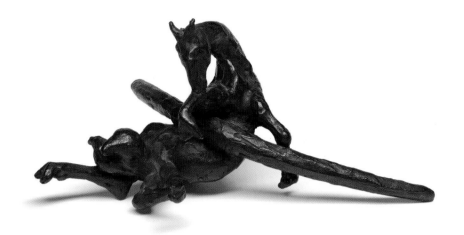

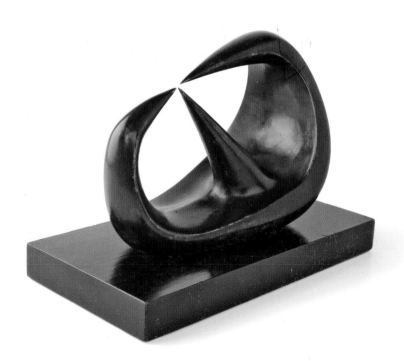

Plate 6
Jack Zajac (b. 1929)
Small Bound Goat, 1962
Bronze
Amon Carter Museum of American
Art, Fort Worth, Texas, gift of Ruth
Carter Stevenson. 1999.16

Plate 7
Henry Moore (1898–1986)
Three Points, 1939–40
Bronze
Extended loan to the Palm Springs
Art Museum, California, from the
collection of Gwendolyn Weiner.
L2007-15.3

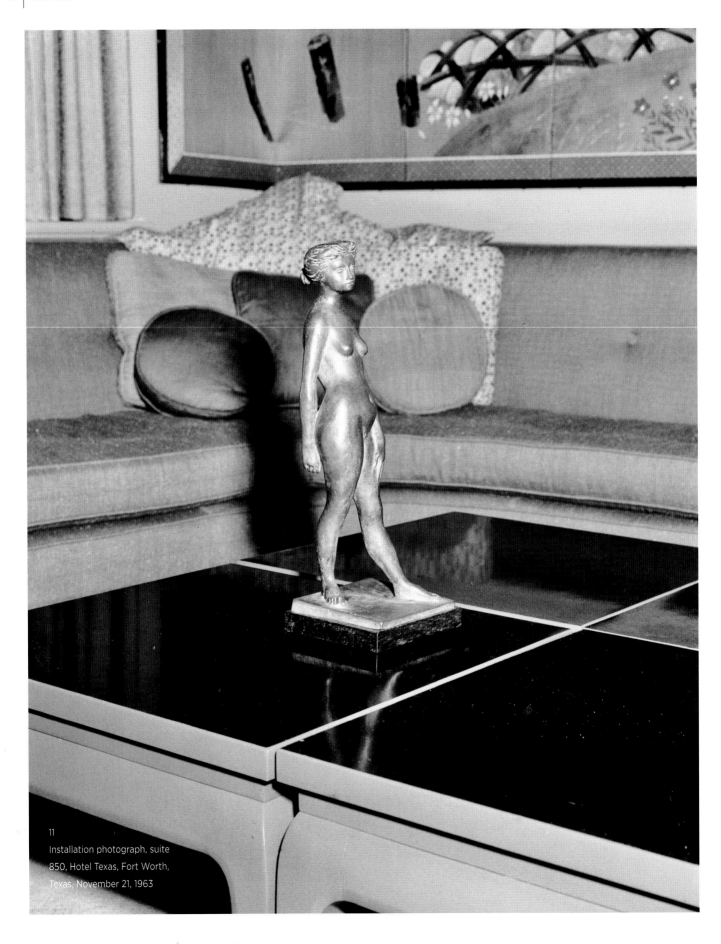

11
Installation photograph, suite
850, Hotel Texas, Fort Worth,
Texas, November 21, 1963

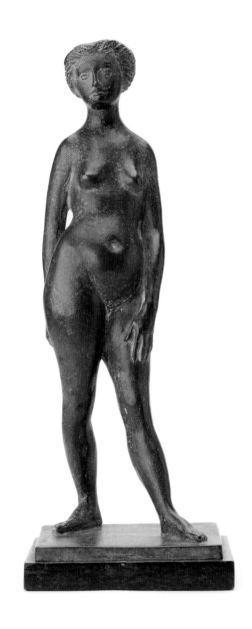

Plate 8
Eros Pellini (1909–1993)
A Girl from Lombardia, 1958–59
Bronze
Extended loan to the Palm Springs
Art Museum, California, from the
collection of Gwendolyn Weiner.
L1980–3.25

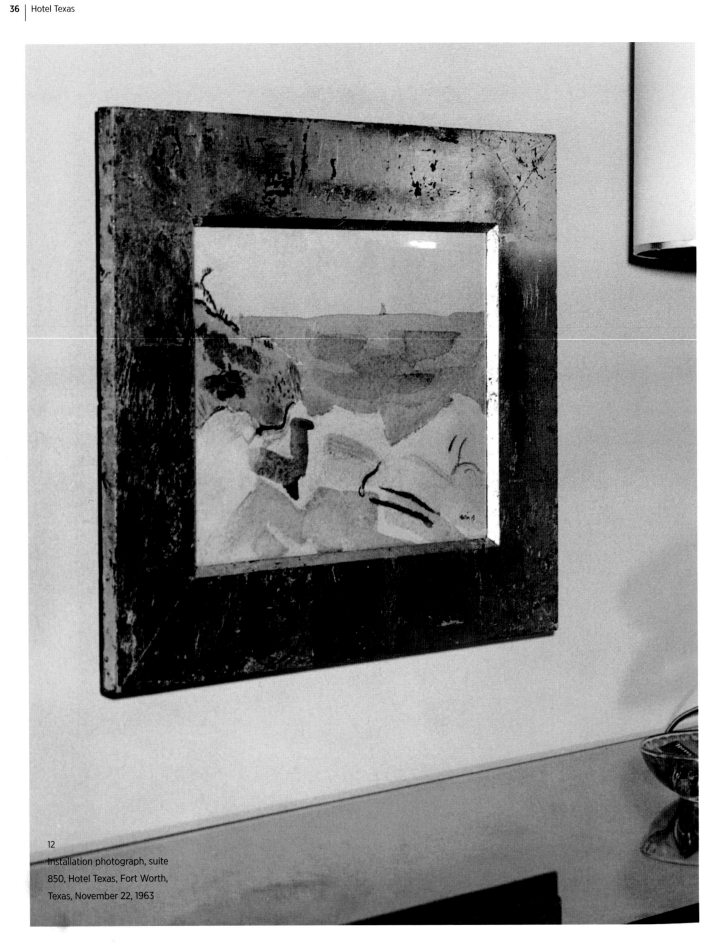

12
Installation photograph, suite
850, Hotel Texas, Fort Worth,
Texas, November 22, 1963

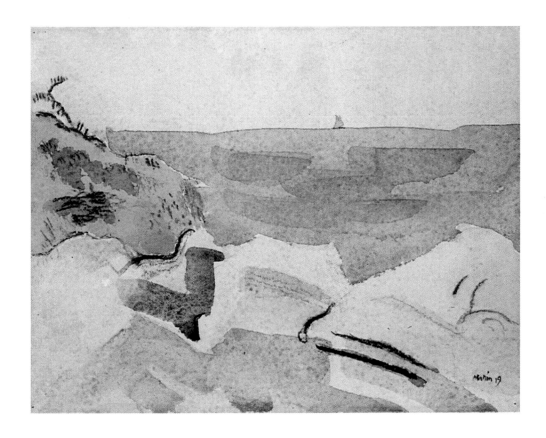

Plate 9
John Marin (1872–1953)
Sea and Rock, Stonington, Maine,
1919
Watercolor on paper
Location unknown

13
Installation photograph, suite
850, Hotel Texas, Fort Worth,
Texas, November 22, 1963

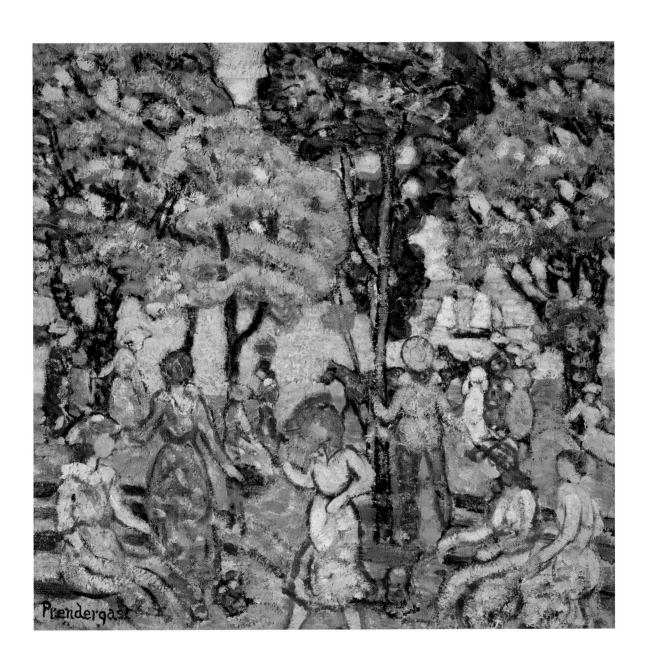

Plate 10
Maurice Brazil Prendergast
(1858–1924)
Summer Day in the Park, 1918–23
Oil on canvas
Private collection, Fort Worth

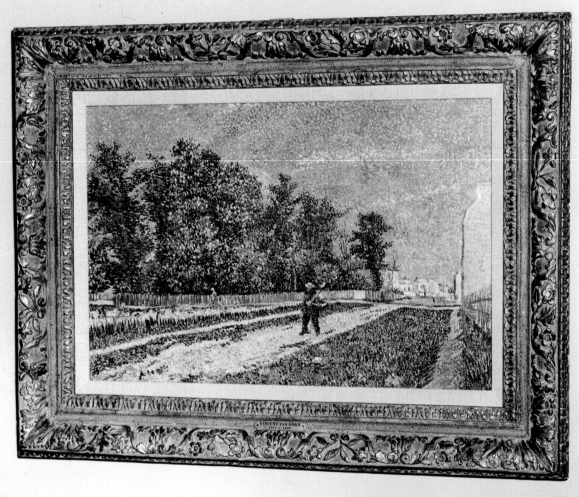

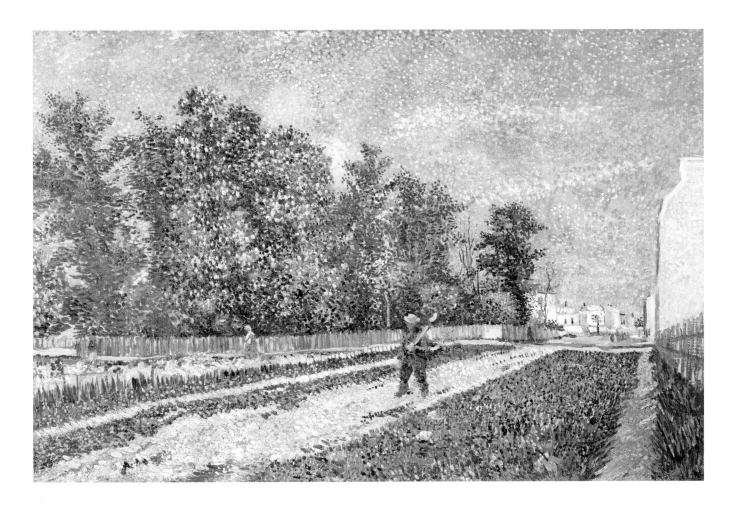

Plate 11
Vincent van Gogh (1853–1890)
Road with Peasant Shouldering a Spade (*Route aux confins de Paris, avec paysan portant la bêche sur l'épaule*), 1887
Oil on canvas
Private collection

15
Installation photograph, suite
850, Hotel Texas, Fort Worth,
Texas, November 22, 1963

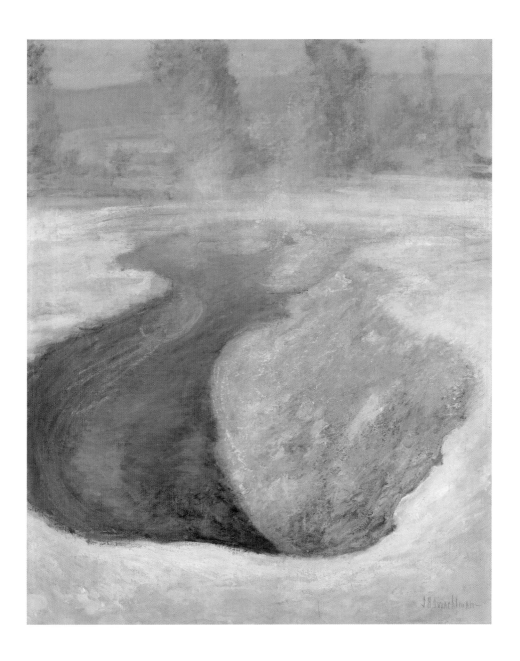

Plate 12
John Henry Twachtman
(1853–1902)
Geyser Pool, Yellowstone,
c. 1890–93
Oil on canvas
Private collection, Fort Worth

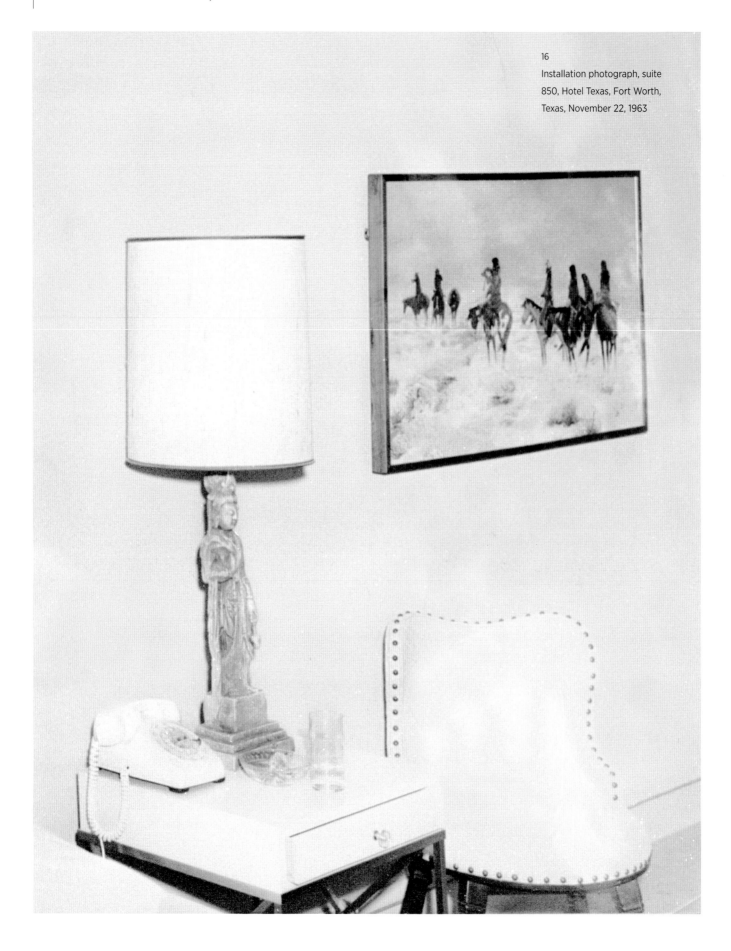

16
Installation photograph, suite
850, Hotel Texas, Fort Worth,
Texas, November 22, 1963

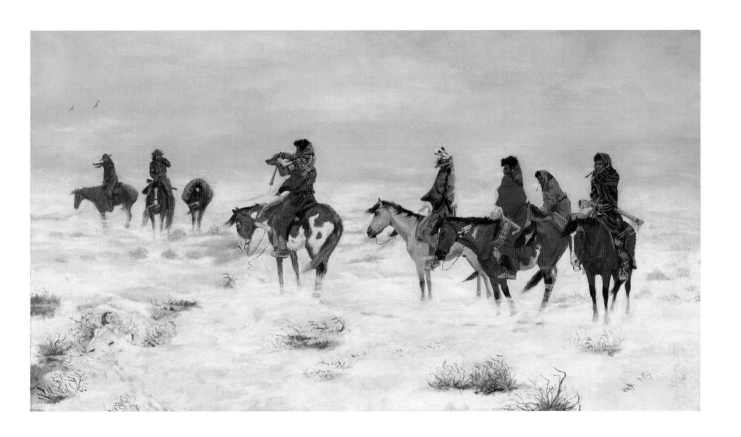

Plate 13
Charles Marion Russell (1864–1926)
Lost in a Snowstorm—We Are
Friends, 1888
Oil on canvas
Amon Carter Museum of American
Art, Fort Worth, Texas. 1961.144

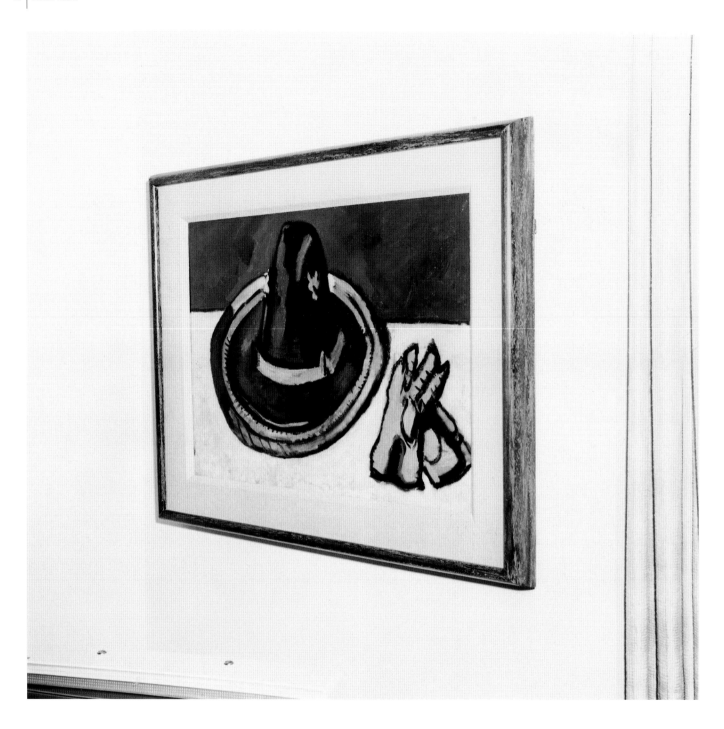

17
Installation photograph, suite
850, Hotel Texas, Fort Worth,
Texas, November 22, 1963

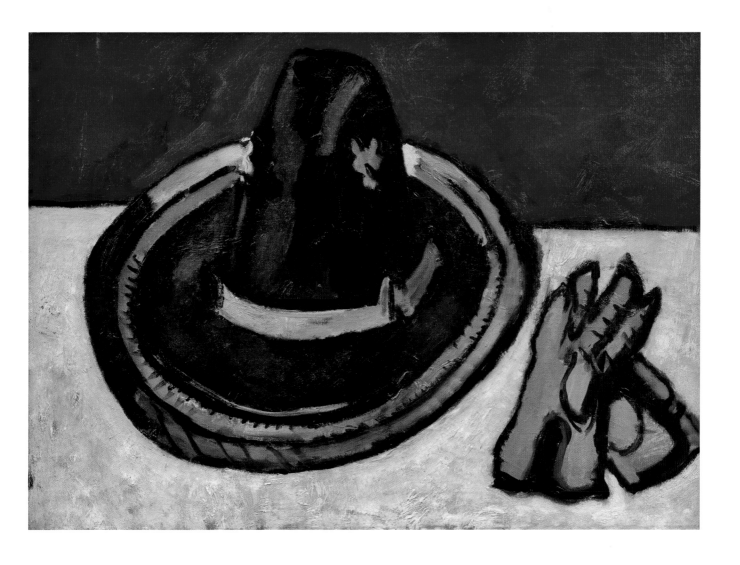

Plate 14
Marsden Hartley (1877–1943)
Sombrero with Gloves, 1936
Oil on canvas
Collection of Katherine Elizabeth
Albritton

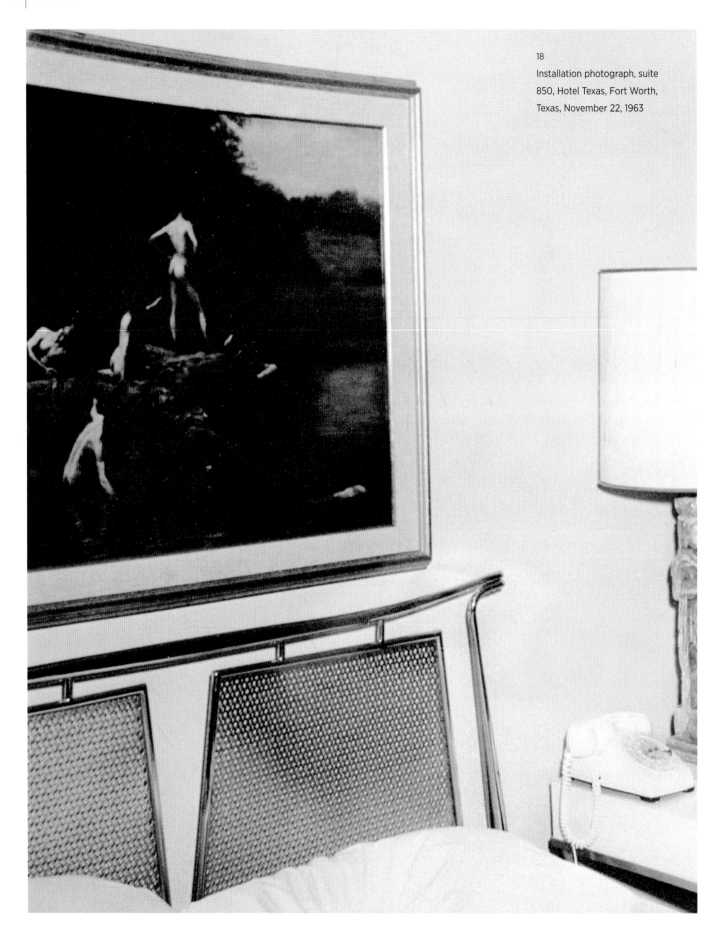

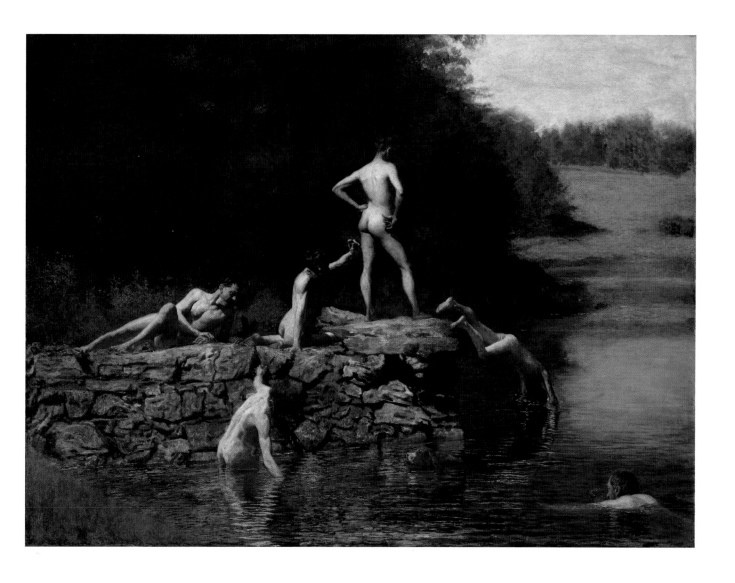

Plate 15
Thomas Eakins (1844–1916)
Swimming, 1885
Oil on canvas
Amon Carter Museum of American
Art, Fort Worth, Texas.
1990.19.1

The Unplanned Farewell: An Art Exhibition for the President and Mrs. John F. Kennedy Scott Grant Barker

Before November 22, 1963, ended in national tragedy, it began with a thoughtful gaze. That morning, art inspired a common bond between President John F. Kennedy and a group of Texans he never met. Their shared experience was made possible by the best of human intentions and art's ability to unite individuals living in separate worlds. Staged in the president's Fort Worth hotel room, *An Art Exhibition for the President and Mrs. John F. Kennedy* evolved from conception to completion in five days. When seen, the exhibition provided an unexpected delight to the Kennedys and opened a window onto the cultural life of one North Texas city (fig. 19). Against the curtain of violence for which this day is remembered, the exhibition becomes a symbolic embrace, an unplanned farewell to the nation's thirty-fifth president and a poignant reminder to us.

The assassination of President Kennedy on November 22, 1963, unleashed a tsunami of shock and sorrow unlike anything most living Americans had experienced. Everyone within the assassination's terrible reach, both at home and abroad, became its victim. There is only so much room in the collective memory of a traumatized nation, and *An Art Exhibition for the President and Mrs. John F. Kennedy* never found a place. Yet, embedded in the timeline of that day, it is there.

The day he died, the president was up early and took the time to look out of his wife's bedroom window at a gathering throng eight floors below and a gray sky above.[1] The crowd of people hoping to see him began forming outside his hotel at dawn. Raincoats and umbrellas were the order of the morning. Mr. and Mrs. Kennedy had arrived at the hotel at around midnight and went directly to their suite on the eighth floor. The previous day had already spawned a kaleidoscope of sights, sounds, and shouted

greetings between the Kennedys and a sea of admirers. Their three-day visit to Texas began with a Thursday morning flight from Washington, D.C., to San Antonio, where the couple was greeted by the first of many warmly enthusiastic crowds. Public appearances in San Antonio and Houston occupied the Kennedys for most of Thursday before *Air Force One* delivered them to Carswell Air Force Base in Fort Worth that night. With Friday, November 22, almost upon them, they had only hours to rest and prepare for a daylong marathon of motorcades and orchestrated appearances in Fort Worth, Dallas, and Austin.

Given the grueling schedule, the Kennedys were exhausted by the time they stepped into the Hotel Texas in downtown Fort Worth. A crowd of about thirty-five hundred people filled the sidewalks and hotel lobby to witness their midnight arrival and to cheer them as they were escorted to the elevator nearby.[2] Their destination was suite 850, a three-room redoubt that was among scores of rooms reserved for the president and his entourage during the twelve-hour stopover in Fort Worth (figs. 20, 21, 22, and 23).

The Kennedys entered suite 850 through a door marked by a polished brass nameplate. In the spacious living room, they found a four-section, Oriental-style coffee table adorned with a large bouquet of yellow roses and mounds of cards from well wishers. The cocktail bar was stocked with Scotch whiskey, soda, and a variety of soft drinks. The carpets were freshly cleaned and the bed in the master bedroom was covered by a new nylon bedspread dyed presidential blue.[3] And something else. Each room featured an exhibition of original fine art, in all, sixteen pieces carefully selected to please a president and First Lady. A catalogue of the paintings and sculptures on view, replete with names such as Monet, Picasso, and van Gogh, lay on the coffee table, its cover

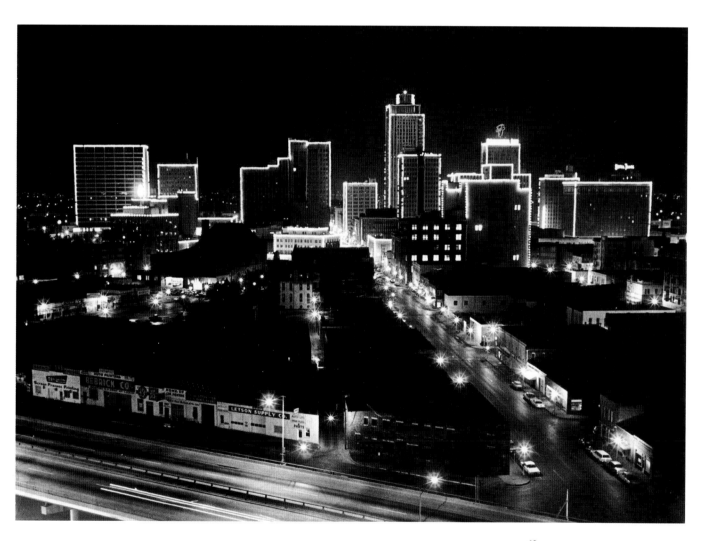

19

The skyline in Fort Worth, with the
buildings outlined in lights in honor
of the visit by President and Mrs.
John F. Kennedy, November 21, 1963

imprinted with the words *An Art Exhibition for the President and Mrs. John F. Kennedy.* This was the most private art exhibition in the history of the city, a display deftly drawn from Fort Worth's public museums and private homes. At that time of night, with a long and demanding day almost behind them, the Kennedys soon retired, not noticing that the art on the walls was put there for them.[4]

A cauldron of reasons drew President Kennedy to Texas in the fall of 1963. The visit was timed by his wish to attend a dinner on November 21 in Houston to honor the veteran Democratic congressman Albert Thomas. It expanded to address needs for fund-raising and solidarity. Several of the state's top Democratic party officeholders, men such as the governor John B. Connally and the senior United States senator Ralph Yarborough, were philosophically worlds apart. There were rumblings about the president's commitment to retaining Lyndon Johnson as vice president in the new term. With the politically powerful Johnson as his running mate, John Kennedy had only narrowly won Texas's twenty-four electoral votes in the general election in 1960. Seeking to shore up his reelection chances and to burnish the Democratic party's image in the eyes of Texas voters, Kennedy agreed to a forty-eight-hour visit that included a star-studded entourage, anchored by Vice President Johnson, Governor Connally, and Senator Yarborough, and a one hundred dollar-a-plate fundraiser in Austin.[5]

Word of the president's impending visit first appeared in Texas newspapers in early November, accompanied by the sensational news that Jacqueline Kennedy would leave seclusion to accompany him. Since August, after the premature birth and death of an infant son, she had been out of the public eye. She was not expected to resume her formal role as First Lady until the end of the year.[6] Mrs. Kennedy rarely accompanied the president on trips that involved fund-raising, and she had never been to Texas.

On November 8, Governor Connally's request to the Fort Worth Chamber of Commerce to reserve 150 rooms at the Hotel

20
Parlor in suite 850, November 21, 1963

21
Parlor in suite 850, showing mirrored wall, November 21, 1963

Texas for the president's arrival on November 21 was made public, along with the president's likely travel schedule. The trip would span much of three days, with overnight stays in Fort Worth and, it was later decided, at the LBJ Ranch outside Johnson City. An ostensibly nonpolitical and nonpartisan breakfast for the president and Mrs. Kennedy and invited guests was immediately booked by the Fort Worth Chamber of Commerce for the morning of November 22 in the Grand Ballroom of the Hotel Texas. The guest list was limited to two thousand people, guaranteeing that the $3 ticket to breakfast with the Kennedys would be the hottest ticket in town.[7]

Art became a major focus of the presidential welcome only five days before the Kennedys flew into Fort Worth, when one man's aesthetic sensibility collided with a catchy newspaper headline and the news beneath it. Owen Day was a regular reader of the Fort Worth *Press,* and he wrote a weekly column, "Art Happenings," for the newspaper, in which he relayed current information about the visual arts in Fort Worth and North Texas.

Day was employed full-time as a designer of trade-show displays for Bell Helicopter Company. A front-page description of the Kennedys' hotel accommodations was published in the *Press* on Sunday, November 17, under the headline "'Suite Eight-Fifty' . . . It'll Be Famous" (fig. 24). From this account, Day learned that the seventy-five-dollar-a-night suite reserved for the president and his wife was not the most luxurious or expensive set of rooms in the Hotel Texas.[8] That distinction belonged to the Will Rogers Suite on the thirteenth floor, where, according to the paper, Vice President and Mrs. Lyndon B. Johnson would stay. In the article, it was reported that no one with knowledge of the room assignments was talking but that suite 850 had one door, whereas the Will Rogers Suite had three, the implication being that, for the president's guardians, the choice of the plainer rooms was rooted in simple practicality.

"Jackie Kennedy, famed for fancying heirlooms for the White House, won't find a single hand-me-down in Suite 850," the reporter, Jean Wysatta, stated, and she went on to describe the

22
Large bedroom in suite 850,
November 21, 1963

23
A. D. Rials, the assistant manager of
Hotel Texas, outside the door to suite
850, November 21, 1963

Fort Worth Press

WEATHER: Cooler, possible showers, low tonight near 40, low 60s Monday.

FOUR SECTIONS

VOL. 43, NO. 39 FORT WORTH, TEXAS, SUNDAY, NOVEMBER 17, 1963 88 PAGES

FINAL
HOME
EDITION
PRICE 10 CENTS

Overnight Home of Kennedys It's Second Expensive at Hotel

'Suite Eight-Fifty'...It'll Be Famous

By JEAN WYSATTA, Press Staff Writer

The brass door plate simply says "Suite Eight-Fifty." After Thursday night it will be famous.

That's the suite in Hotel Texas where President and Mrs. John F. Kennedy will spend the night before the Friday breakfast.

The two-bedroom lay-out is the second most expensive at the hotel. It costs $75 per night. Only the Will Rogers Suite on the 13th floor is more expensive. It costs $100 a night.

No one would talk about why the cheaper suite was selected or by whom.

Jackie Kennedy, famed for fancying heirlooms for the White House, won't find a single hand-me-down in Suite 850. Not even an old rocking chair. Not even a cowboy or Indian print by the famous Russell.

SUITE 850 IS CHINESE MODERN.

Mrs. Kennedy would have viewed Russell's western art had she stayed in the Will Rogers Suite.

In 850's master bedroom there is a picture on the wall. It looks like a village in Europe. A heavy snow has fallen. Turquoise is the shade used in draperies and for spread for the king-size bed.

The suite has three bathrooms.

THE SPACIOUS PARLOR has windows that overlook Eighth and Commerce Sts. for a view of a bus station and parking lot.

Dutch blue walls and draperies with accents of jade green and gold are used in the parlor. A Chinese wall screen in gold hangs to one side of a sand-colored corner sofa. The rug is gold with a floral design. A heavy black coffee table in four sections sits in front of the sofa.

If the President and his wife feel like getting into a card game, the parlor has a game table with four chairs.

The small bedroom has a regular-size, double bed and otherwise plain furnishings. The dresser has a large blue vase flowing with a dried arrangement.

THE KENNEDYS might have sat on Ritz Carlton instead of Chinese modern had they taken the Will Rogers Suite. It is furnished with tables, fireplaces and other pieces from the New York's Ritz Carlton Hotel, which was torn down in 1949 and 1950. The late Amon Carter purchased the furnishings for Hotel Texas, even down to the hardware and solid oak doors.

Will Rogers Suite has three of those doors opening to the outside hallway. Suite 850 has only one door opening outward.

The minute it was learned last Thursday the President would spend the night here, preparations were started to make a little White House out of Suite 850. Telephone company employes began to hook up special communications for the President and his party. A direct telephone line to Washington is being installed.

HOTEL MAIDS and cleaning men began eying Suite 850 in a new way. A light bulb was dead in the lamp in the master bedroom. The woodwork needed some touching up. The gold rug needed cleaning. But, otherwise no extensive redecorating would be done.

The $75 a night suite will be on the house, says B. B. Stroud, executive assistant manager. No president, vice president or senator is billed for staying at Hotel Texas. That's the hotel custom. But a president has never spent the night at Hotel Texas, as far as Mr. Stroud can recall. He's been with the hotel since 1935. Lady Bird Johnson, here this year, stayed in Will Rogers Suite.

The hotel kitchen was also preparing special grocery orders. The breakfast menu will be bacon, eggs and hash brown potatoes. Several hundred pounds of bacon will be ordered.

And President and Mrs. Kennedy, along with all other Catholics at the breakfast, will be allowed to eat meat on Friday. The traditional fasting is always dispensed with on special occasions. And so it will be on this one.

Total Spending on F-111 Could Zoom To $10 Billion Top

—Story on Page 3

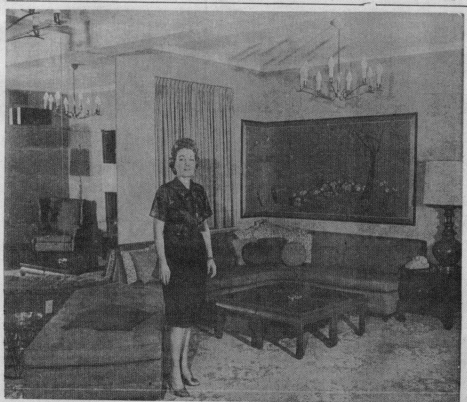

Focal point of the parlor in Kennedy suite . . . Mrs. Robbie Snelson, reservations employe, stands where First Lady will walk.

suite in some detail. The space consisted of a living area, a master bedroom, a smaller bedroom, and three bathrooms. Situated at the southeast corner of the hotel's eighth floor, it afforded unobstructed views of a bus station and parking lot across the street. The living room décor was vaguely Chinese in theme and included a gold screen, a sand-colored corner sofa, and a heavy, black coffee table in four sections. Walls were painted Dutch blue. For the first couple's amusement, the living area sported a grouping of four chairs and a game table, suitable for playing cards. In the article, one corner of the living room was pictured in a photograph.

The two bedrooms were nondescript. The master bedroom's color scheme consisted of a bedspread and draperies dyed a coordinating blue. A painting on one of the walls depicted what appeared to be a European village under a heavy blanket of snow. The small bedroom contained "a regular-size, double bed and otherwise plain furnishings. The dresser has a large blue vase flowing with a dried arrangement." The reporter mentioned that if the Kennedys stayed in the Will Rogers Suite they would be surrounded by fine furnishings that once graced the Ritz Carlton Hotel in New York, a wry observation that was completely true. With suite 850's shortcomings so pointedly spelled out, Owen Day (fig. 25) decided that something should be done to fix them. To his way of looking at it, the idea of creating a customized art experience for the Kennedys was the perfect solution.[9]

It is one thing to think of art as a bridge between a host city and a visiting president of the United States; it is quite another to put the bridge in place in a matter of days. One phone call to the right person was enough to set Day's proposition into motion. That his idea succeeded was emblematic of the small-town dynamics that governed social life in this North Texas city of three hundred and fifty thousand residents, where word traveled fast and names readily opened doors.

On Monday morning, Day called Samuel Benton Cantey III (fig. 26) to make the case for filling suite 850 with original art.

Day had observed Cantey in action on numerous occasions and correctly judged that Cantey's social standing and passion for art made him the likely architect of any exhibition for the presidential couple. Cantey, who worked as vice president of public relations for the First National Bank of Fort Worth, occupied a prominent position in society circles as a patron of the visual arts and all-around authority. He had been a prime mover behind the funding and construction of the Fort Worth Art Center, the city's first public art museum. (Today this is the Modern Art Museum of Fort Worth.) For his activism, most who knew Cantey thought of him as a museum director in banker's clothing. Sam Cantey listened to Day's idea and liked it for all the reasons Day had counted on.

Ruth Carter Johnson (later Stevenson) did not support Kennedy politically and did not vote for him in 1960. This, however, presented no obstacle, and she immediately agreed to assist him when Cantey phoned with the idea of "bringing the museums to the Kennedys."[10] The daughter of the late newspaper magnate Amon G. Carter Sr., the publisher of the Fort Worth *Star-Telegram*, Johnson had grown up in the presence of an iconic man who, for almost fifty years, steered Fort Worth's business and political life with the grit of a benevolent autocrat. After Carter's death in 1955, she was entrusted with the board chairmanship of the foundation bearing his name and charged with building a museum to house his beloved collection of works by Frederic Remington and Charles Marion Russell. Under her guidance, the Amon Carter Museum of Western Art (now the Amon Carter Museum of American Art) opened in 1961. Johnson and Sam Cantey were neighbors, and she had known him for years, so her decision to place the resources of the Amon Carter at his disposal was not a difficult one to make.[11]

With the clock counting down to the Kennedys' arrival, the efforts of Cantey, Day, and Johnson during the week of November 18 unfolded largely in public. Their plans became known through articles and brief columns that ran in both of the

24
The article titled "'Suite Eight-Fifty' . . . It'll Be Famous," which appeared in the Fort Worth *Press* on November 17, 1963, provided much of the initial impetus for the exhibition

city's daily newspapers and were augmented by a smattering of photographs taken in and around the presidential suite. Access to suite 850 was too restricted and the exhibition's life span too short to allow for extensive photography. It was due to Day's instincts that *An Art Exhibition for the President and Mrs. John F. Kennedy* was photographed almost in its entirety, and then only at the last minute.

The first reference to the exhibition appeared on Tuesday, when the Fort Worth *Press* reported that Cantey, Day, and Johnson were "going through channels to get the snow scene off the wall in Suite 850" and to "nab the gold Chinese screen from behind the corner sofa."[12] A member of the planning group was quoted as saying that the president and Mrs. Kennedy should not be exposed to "pictures like that." The article also carried the short-lived news that the exhibition might consist of top-notch Texas art. Landscape paintings by Porfirio Salinas of San Antonio were personal favorites of both Lyndon Johnson and John Connally, and other well-known members in the hierarchy of Texas painters were considered. But the concept of an all-Texas exhibition was abandoned within twenty-four hours

when Johnson claimed that the suite was too small to hold a representative selection of the best work. For Cantey, who collected local and American contemporary art, and Johnson, whose taste in art was decidedly French, the all-Texas proposal was likely an exercise in political correctness, as evidenced by the course they actually took.

On Wednesday morning, while the Fort Worth *Press* reported the demise of the all-Texas idea, the Fort Worth *Star-Telegram* published a virtually complete description of the art installation intended for suite 850.[13] With lightning-fast decisions, Sam Cantey and Ruth Johnson chose the exhibition in a day. Wednesday's *Star-Telegram* story also revealed the core reasoning behind their selections: "Because of Mrs. Kennedy's appreciation of the arts, we thought it would be a special pleasure for her and the president to have an opportunity to see some choice items from Fort Worth collections," Johnson stated. Like most Americans, Cantey and Johnson viewed Jacqueline Kennedy as exceptionally refined. She had studied in France and was fluent in the language. As First Lady, she charmed and disarmed the French president Charles de Gaulle during

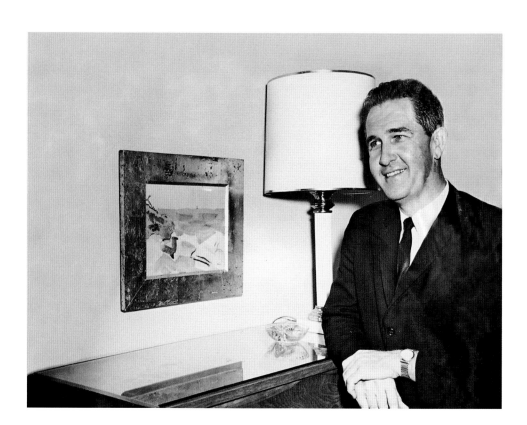

25

Owen Day, whose idea it was to assemble the art exhibition in suite 850, with *Sea and Rock, Stonington, Maine* by John Marin, November 22, 1963

a triumphant state visit to Paris in 1961, an event still fresh in many Americans' minds. In 1962, she led the nation on a televised tour of a meticulously refurbished White House, a broadcast that almost sixty million Americans watched. From support of the performing arts to fashion, her effect on popular culture was immense. If *An Art Exhibition for the President and Mrs. John F. Kennedy* was going to please anyone, Cantey and Johnson wanted it to be her.

Mindful of Jacqueline Kennedy's eye for quality and French culture, Cantey and Johnson chose sixteen paintings and sculptures for the exhibition. Artworks were borrowed from the Amon Carter, the Fort Worth Art Association, and five private collections, including those of the curators. Once the works had been chosen, Cantey sent the checklist to the First National Bank print shop and requested a hundred copies of a printed catalogue.[14] The artworks were picked up in the middle of the week, gathered by couriers sent out from the Amon Carter, and installed at the hotel on Thursday morning, November 21. Two late additions, a sculpture by Pablo Picasso and a painting by Raoul Dufy, made the trip downtown in Johnson's station wagon. A photographer for the

Star-Telegram ceremoniously recorded the moment when the Picasso bronze was strapped into the front seat of Mrs. Johnson's car with a seatbelt (see fig. 34).[15]

To serve as backdrops for these sixteen works of art, suite 850's three rooms functioned as individual galleries, each one offering a different visual experience from the neighboring spaces (fig. 27). It was reported at the time that Mitchell Wilder, the director of the Amon Carter, made a detailed sketch of the placement of the artworks throughout the suite.[16] Wilder's sketch has never been found, leaving written descriptions and extant photography as present-day guides to how *An Art Exhibition for the President and Mrs. John F. Kennedy* was physically arranged.

The master bedroom was an interior room with limited views to the outside. It was there that Cantey and Wilder placed four paintings meant for Jacqueline Kennedy. The paintings, all outdoor scenes, were notably rooted in French impressionism. The most important was *Road with Peasant Shouldering a Spade* (plate 11), painted outside Paris in 1887 by Vincent van Gogh using a pointillist technique. The only other van Gogh in the United States that is similar in style is in the collection at Yale

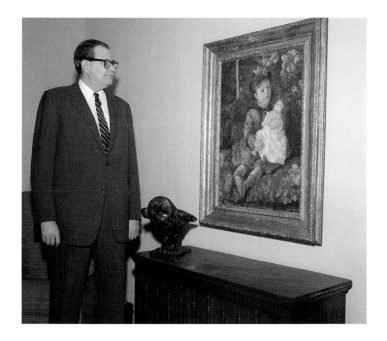

26

Sam Cantey III, the executive vice president of the Fort Worth Art Association, in suite 850, with *Portrait of the Artist's Granddaughter* by Claude Monet and *Angry Owl* by Pablo Picasso, November 21, 1963

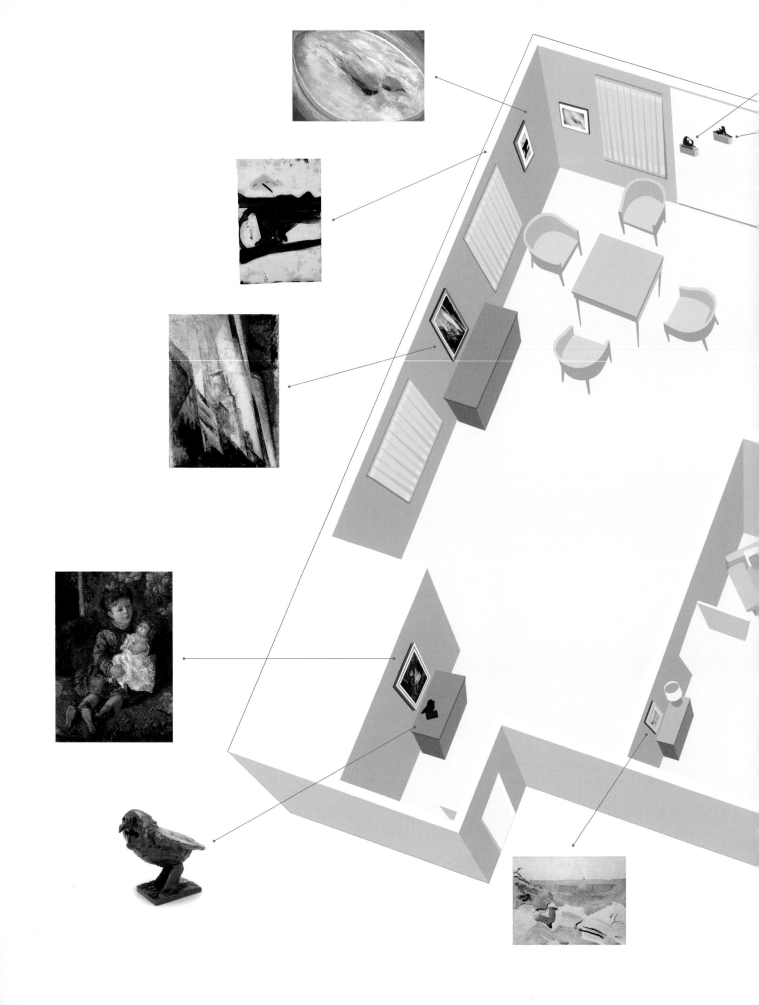

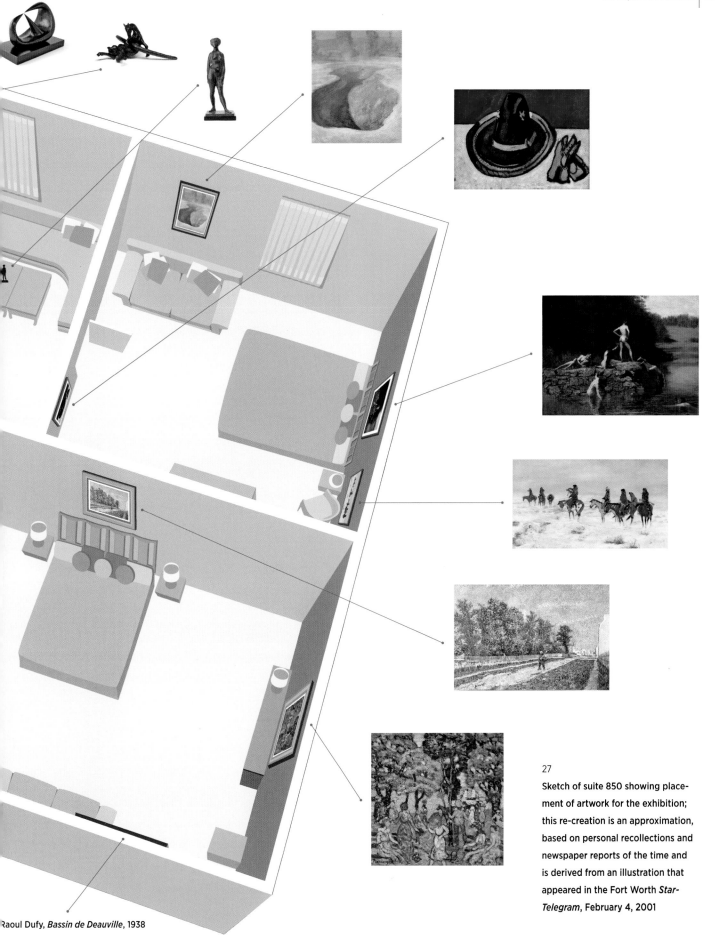

27

Sketch of suite 850 showing place-
ment of artwork for the exhibition;
this re-creation is an approximation,
based on personal recollections and
newspaper reports of the time and
is derived from an illustration that
appeared in the Fort Worth *Star-
Telegram*, February 4, 2001

Raoul Dufy, *Bassin de Deauville*, 1938

University. Johnson had purchased the van Gogh masterpiece in the late 1940s, encountering the displeasure of her father the first time he saw it.[17]

Complementing the van Gogh landscape was a harbor scene, *Bassin de Deauville,* painted by Raoul Dufy and owned by Perry Bass, an oil magnate in Forth Worth. Two American works rounded out the display in the master bedroom. They were *Sea and Rock, Stonington, Maine* (plate 9), a small watercolor by John Marin, and *Summer Day in the Park* (plate 10), a leisurely, late work by the American impressionist Maurice Prendergast. Cantey had acquired the Marin in 1950 from Knoedler and Company, New York;[18] the Prendergast, owned by William Marshall Fuller, also an oil magnate, had originally come from the estate of the artist's brother Charles.[19]

Through a multipaned window, suite 850's smaller bedroom offered views to the south and street below. The presence of the window made it unlikely that President Kennedy would spend the night there; nevertheless, the second bedroom became the space decorated for him. This bedroom was outfitted with four distinctly American works, anchored by Thomas Eakins's *Swimming* (plate 15).[20] Depicting exquisitely painted nude swimmers and having a checkered past, *Swimming* was the most important nineteenth-century American painting in the city. Its completion had figured prominently in Eakins's expulsion, despite his stature as an artist and teacher, from the Pennsylvania Academy of the Fine Arts in 1886. Arriving quietly in Texas in 1925, *Swimming* was the only nude painting in the collection that was not customarily turned to the wall when youngsters were present in the Fort Worth public art gallery.[21] At the time of the Kennedys' trip to Texas, *Swimming* was generally recognized as a masterpiece.

Complementing *Swimming* was a painting once owned by Amon Carter himself, *Lost in a Snowstorm—We Are Friends* (plate 13), created in 1888 by Charles Marion Russell.[22] Depicting an encounter between two white cowmen and five Blackfeet Indians during a fierce winter storm, Russell's snowy tableau spoke eloquently of the fundamental similarities that all humans share. Rounding out the offerings in the second bedroom were paintings by John Twachtman and Marsden Hartley. They were *Geyser Pool, Yellowstone* (plate 12), painted by Twachtman in 1895 during an extended tour of Yellowstone National Park; and *Sombrero with Gloves* (plate 14), a modernist work by Hartley that radiated a regional, Hispanic theme.

Suite 850's living room, or parlor as it was called, became the third exhibition space, and it was here that Sam Cantey and Mitchell Wilder installed a compact display of contemporary paintings and sculptures. Of the six pieces, the major painting on display was *Manhattan II* (plate 3), an oil-on-canvas work by Lyonel Feininger. The painting entered Fort Worth's public art collection in 1946, just as Feininger's postwar popularity among the city's private collectors was soaring. Also obtained from the public collection was *Spirit Bird* (plate 4), a work on paper by Morris Graves. *Spirit Bird* had been given to the Fort Worth Art Association upon the death of its owner, William Edrington Scott, who had been a close friend of Cantey. Three of the six works in the living room came from Ted Weiner, a wealthy oil and gas producer with a remarkable appetite for modern art.[23] By 1963, Weiner owned a collection of modern sculpture unequalled in the state, as well as many paintings and works on paper. From the Weiner collection, Cantey borrowed *Three Points* (plate 7), a geometrically precise bronze by the English sculptor Henry Moore; *A Girl from Lombardia* (plate 8), a standing nude figure by the Italian sculptor Eros Pellini; and *Study for Accent Grave* (plate 5), an oil sketch on paper by the abstract expressionist painter Franz Kline.

Added to the modern sculpture was *Small Bound Goat* (plate 6), a small bronze by the Californian artist Jack Zajac. This work, like the van Gogh landscape, was supplied by Johnson. Cantey and Wilder took the bronze sculpture by Zajac and *Three Points* by Moore and placed them on narrow, wooden pedestals affixed to the living room's mirrored south wall. They perched the *Girl from Lombardia* in the center of the black, four-section coffee table. Filling out the display, *Spirit Bird* and *Study for Accent Grave* were hung in a corner of the living room, near *Manhattan II*.

Two works of art were installed in suite 850's entryway, just inside the door, to serve as visual introductions to what lay within. Here Cantey and Wilder placed *Angry Owl* (plate 2), a bronze piece by Pablo Picasso. It, too, was borrowed from Ted Weiner's extensive collection. Paired with the bronze bird was *Portrait of the Artist's Granddaughter* (plate 1) by the French impressionist Claude Monet. This tender portrait entered the private collection of Johnson's family as a gift from her mother. The Monet was hung on a wall just inside the suite's front door; the Picasso sat on a tabletop beneath the painting.[24]

Johnson and Day were present in suite 850 on Thursday morning as Cantey, Wilder, and Wilder's assistant, Brownie Brown, hung the show. All were told to remove their shoes before entering the suite on orders of the hotel's head housekeeper, Iva Estes, who was frustrated at how quickly the carpets were becoming soiled by all the unwanted foot traffic.[25] As an extra measure of protection, she spread sheets across the carpets to try to keep them clean. Where Jacqueline Kennedy could not fail to see it, Vincent van Gogh's *Road with Peasant Shouldering a Spade* was hung over the headboard in the master bedroom. Over the headboard in the second bedroom, where the president might decide to stay, Wilder and Brown hung *Swimming.* Each masterpiece was surrounded with its supporting cast of art in hopes that the Kennedys would notice and come away with a positive and lasting impression.

In a spate of last-minute activity, Johnson directed Wilder to decorate Vice President Lyndon Johnson's suite with art from the vaults of the Amon Carter.[26] Mrs. Johnson, who was a personal friend of Lyndon and Lady Bird Johnson, became worried that the vice president and his wife might be offended, or feel overlooked, if something special wasn't done for them. For that reason, Mitchell Wilder selected and installed a sizeable exhibition of western art in the Will Rogers Suite later that day.[27] Before she left the hotel, Mrs. Johnson was asked by a Secret Service agent to come back on Friday morning. She was to come up to the eighth floor and wait near the elevator, where, as he was leaving, the president would shake her hand. The president, the agent said, would want to thank her for the efforts made on his behalf.[28]

Day was worried that *An Art Exhibition for the President and Mrs. John F. Kennedy* had not been properly documented and brought a co-worker, Byron Scott, up to suite 850 to take pictures.[29] Scott was a photographer for the Bell Helicopter Company and had been assigned to cover the president's visit. That Thursday morning, the Secret Service allowed Scott to take pictures only in the living room. The bedrooms were off limits, Scott was told, and would have to be accessed the next day, after the Kennedys were gone. Elsewhere in the suite, a photographer from the Fort Worth *Star-Telegram* took a picture of Cantey standing in the entryway, admiring the Picasso sculpture and the Monet portrait. A photographer from the Fort Worth *Press* waited in the hallway outside and took a picture of a kneeling Cantey putting his shoes back on.[30] When Scott was finished, everyone

in the space was ushered out and the door locked in expectation of the Kennedys' arrival.

John and Jacqueline Kennedy made it to the Hotel Texas shortly before midnight on Thursday. Despite the hour, more than five thousand citizens of Fort Worth greeted them at Carswell Air Force Base, and thirty-five hundred more waited for them at the hotel. President and Mrs. Kennedy made their way through a packed lobby and went directly to their suite on the eighth floor. The president ordered a pot of coffee to be sent to the suite about forty-five minutes later.[31] Some time after that, the couple retired for the night. Despite Cantey's planning, and for reasons known only to their guardians, Jacqueline Kennedy took the small bedroom and John Kennedy the larger.[32]

The next morning the president made a brief public appearance outside the hotel at ten minutes to nine, and shortly after that he delivered a breakfast speech to two thousand invited guests in the hotel's Grand Ballroom. He and Mrs. Kennedy left the Hotel Texas at 10:40 on Friday morning, November 22, 1963.

Ruth Carter Johnson did not return to the Hotel Texas that morning. One of her daughters became ill during the night, and Johnson stayed home to care for her.[33] The Secret Service agent who requested her presence had also given her a contact number in case something came up. Johnson called the number early on Friday morning to say that she would not be coming. Therefore, she was at home when John Kennedy's call came in a little after ten o'clock. An aide to the president spoke first, to confirm that he had reached the right person. Then the president came on the line and told her how much it meant to him and his wife to be surrounded by so much wonderful art. He appreciated the efforts of Johnson and the others. Johnson, surprised to be speaking directly with the president, barely knew what to say.[34] "He said it was all very beautiful and he thanked us very much," she told a reporter later.[35] Then Jacqueline Kennedy came on the line. Johnson was struck by how small the First Lady's voice sounded; so small for someone of Mrs. Kennedy's stature. Jacqueline Kennedy told Johnson that, when they arrived in the suite near midnight, she and the president had been exhausted. They went to bed not realizing that the art on the walls was real. That morning, as Mrs. Kennedy walked through the rooms, she picked up one of the small catalogues prepared by Cantey and the printers at the bank and was swept away by what she read. Mrs. Kennedy said she didn't want to leave; it was all too beautiful to let it go so

quickly.[36] Then the call, Kennedy's last phone conversation with someone in the outside world, was over. And the Kennedys did go, as duty said they must, out Henderson Street, the Jacksboro Highway, and River Oaks Boulevard, past the noisy, adoring Fort Worth crowds and the Castleberry High School band, to the waiting plane at Carswell Air Force Base, and on to the tragic future that no American, except one, had chosen for them.[37]

Day and Scott returned to the door outside suite 850 shortly after the Kennedys left and once again asked for permission to enter. Scott was back at the hotel that morning to take photographs of Bell Helicopter executives attending the breakfast and of President Kennedy on the ballroom stage. After a half-hour's wait and accompanied by an assistant hotel manager, they entered the suite and toured the two bedrooms where John and Jacqueline Kennedy had stayed. In the master bedroom, newspapers lay strewn about the floor beside the bed. A bottle of mineral water sat on one bedside table and a small pill bottle sat on the other. In the bathroom Day observed daubs of shaving cream on the counter, water splashed on the floor, and a towel carelessly tossed in the tub. It was apparent that a man, President Kennedy, had occupied this room.[38]

In the small bedroom, Scott photographed *Swimming* hung over the rumpled twin-sized bed. Day noted how neat the bedroom was. In the tiny bathroom he counted six splatters of makeup on the counter. It was clear to him that the room earmarked for the president had been occupied instead by his wife. Day and Scott finished the photography session and parted ways a little before 12:30 P.M.[39] As he left suite 850, Day asked the assistant hotel manager, B. B. Stroud, whether he could take one of the roses from the vase on the coffee table as a souvenir. Stroud nodded his assent, and Day happily tucked a single yellow rose in his pocket.[40]

A few minutes later on Elm Street in Dallas, thirty miles away, high-powered rounds screamed from a distance into the president's open limousine. One bullet struck President Kennedy in the back of his neck, the next struck the back of his head. For each American who lived through it, the moment, 12:30 P.M. Central Standard Time, was forever frozen in personal memory. At that hour, in less than seven seconds, the tragic future was revealed. The president was declared dead at Parkland Hospital half an hour later, but by any practical measure he died there in the car, just after 12:30, cradled in the arms of his wife. Governor Connally was hit too and, after frantic efforts at Parkland to save both men, somehow lived.

Brown was standing in the middle of the king-sized bed, taking the van Gogh off the wall, as word of the shooting filtered into suite 850. Day was walking back to the *Press* offices at Fifth and Jones streets when a man he had never seen before began yelling the unbelievable news. Day's first reaction was to wonder why the man was yelling at him. His second reaction was that what he had just heard was strictly impossible. He had seen the president only an hour ago. Later, when Scott developed the pictures from the president's suite, Day regretted that there weren't more of them.[41] They were, after all, photographs of the last place where, surrounded by art, the president had been safe.

Swept away by an avalanche of events, suite 850 and *An Art Exhibition for the President and Mrs. John F. Kennedy* would be no more than footnotes in the lore of that terrible November day. Only in the minds of the few who saw it would memories of the exhibition live on.[42] Quietly, the paintings and sculptures were returned to the places from where they had come. In the years following the assassination, some of the art, such as Johnson's van Gogh and Ted Weiner's sculpture collection, left Fort Worth. Suite 850 never did become famous. After the disastrous outcome of President Kennedy's visit to Texas, there was no passion for creating a shrine in the middle of a working hotel. Suite 850 disappeared in the 1980s when the Hotel Texas, under new owners and a new name, was gutted and its interior completely rebuilt. For the longest time, a small display of photographs on the mezzanine was the only reminder that President Kennedy spent his last night there.[43]

In 1963, hundreds of men and women in Tarrant County were involved in preparations for the president's visit. One small group of them was given a special opportunity, and they took it. Along with the accolades and warm applause, added to the cheers and shouted greetings, they gave him the experience of art. It was a surprise counterpoint to daily Fort Worth life, something John Kennedy didn't expect to see even when it was right in front of him, an impromptu gesture on the eve of a tragedy no one could predict. Against the curtain of violence for which this day is remembered, the exhibition conceived by Cantey, Day, and the others is an echo of our better selves and hard evidence of our collective loss.

1 William Manchester, *The Death of a President: November 20–November 25, 1963* (New York: Harper and Row, 1967), 112.

2 John Ohendalski, "Signs Are Friendly to JFK," *Fort Worth Press,* 22 November 1963.

3 "Presidential Suite Placed Under Strict Secret Service Vigilance," *Fort Worth Star-Telegram,* November 21, 1963, evening edition.

4 Manchester, *Death of a President,* 120–21.

5 Fort Worth newspapers characterized President Kennedy's trip as nonpolitical; however, the author William Manchester more accurately described the itinerary as being segregated into political and nonpolitical components (ibid., 21).

6 Ibid., 8–10, 15.

7 John Tackett, "It'll Be First-Come-First-Served on JFK Tickets," *Fort Worth Press,* November 17, 1963.

8 Jean Wysatta, "'Suite Eight-Fifty' . . . It'll Be Famous," *Fort Worth Press,* November 17, 1963.

9 Owen Day, interview with the author, April 12, 1999. Archives of the Amon Carter Museum of American Art. In describing his motivations for proposing the exhibition, Day did not specifically remember the Wysatta article as the primary spark; however, a newspaper account written at the time stated that it was ("Texas Art for Walls of Kennedys' Suite?," *Fort Worth Press,* November 19, 1963).

10 Ruth Carter Stevenson (formerly Mrs. J. Lee Johnson III), interview with the author, March 31, 1999. Archives of the Amon Carter Museum of American Art.

11 Ibid.

12 "Texas Art for Walls of Kennedys' Suite?," *Fort Worth Press,* November 19, 1963.

13 "Art Treat Awaiting Kennedys," *Fort Worth Star-Telegram,* November 20, 1963, morning edition.

14 "Art Exhibit Compiled By Patrons: Catalog Printed for JFK, Wife," *Fort Worth Star-Telegram,* November 22, 1963, morning edition. Each catalogue was hand numbered. Cantey inscribed copy 1 and copy 2 to President and Mrs. Kennedy. Copies 20 through 29 were placed on the coffee table in suite 850's living area. The remaining copies were later distributed to libraries, educational institutions, and members of Sam Cantey's social circle.

15 "Top Fort Worth Art Décor for Kennedys," *Fort Worth Star-Telegram,* November 21, 1963, morning edition.

16 Ibid.

17 Judy Wiley, "The House That Ruth Built: An Eye for Art, a Heart in Fort Worth: Carter's Museum Turns 50," *360 West Magazine* (January 2011), 72.

18 Samuel Benton Cantey papers, 1944–1978, *Archives of American Art,* Smithsonian Institution, reel 1692, frame 310.

19 Carol Clark, *American Impressionist and Realist Paintings and Drawings from the William Marshall Fuller Collection,* exh. cat. (Fort Worth, Texas: Amon Carter Museum of Western Art, 1978), 46.

20 In 1963, *Swimming* was widely known as *The Swimming Hole* or *The Old Swimming Hole.* Scholarly research into the painting's history led to its renaming in 1996 (Doreen Bolger and Sarah Cash, eds., *Thomas Eakins and the Swimming Picture* [Fort Worth, Texas: Amon Carter Museum, 1996]).

21 Reilly Nail, *Origins of the Fort Worth School,* panel discussion, transcript, Modern Art Museum of Fort Worth, April 14, 1992.

22 In 1963, this painting by Russell was known by an alternative title, *Meeting in a Blizzard.* Scholarly research into the painting's history led to its being renamed as *Lost in a Snowstorm—We Are Friends.*

23 *The Sculpture Collection of Mr. and Mrs. Ted Weiner,* exh. cat. (Fort Worth: Fort Worth Art Center, 1959); *The Collection of Mr. and Mrs. Ted Weiner,* exh. cat. (Austin: Art Museum of the University of Texas, 1966).

24 "Presidential Suite Placed Under Strict Secret Service Vigilance," *Fort Worth Star-Telegram,* November 21, 1963, evening edition.

25 Bill Hendricks, "Off With Those Shoes Is Order To Those Visiting JFK Suite," *Fort Worth Press,* November 21, 1963. Ruth Carter Stevenson also recalled being told to remove her shoes before entering suite 850 (interview).

26 Stevenson, interview; see also, Owen Day, "Kennedy Suite Held $100,000 Collection," *Fort Worth Press,* November 24, 1963.

27 "Items exhibited in the Presidential and Vice-Presidential Suites, Nov. 21–22, 1963," typescript, archives, Amon Carter Museum of American Art, Fort Worth, Texas.

28 Stevenson, interview.

29 Day, interview, n. 9.

30 Hendricks, "Off With Those Shoes." The photograph appeared above the caption "Shoeless Sam . . . the bank and art man."

31 John Moulder, "All Night Vigil For the Lawmen," *Fort Worth Press,* November 22, 1963.

32 William Manchester, *The Death of a President,* serialized, *Stern* (Germany), January 22, 1967, 34–36. See also Arthur Greenspan and Norman Poirier, "*Stern* Tells of JFK's Last Night," *New York Post,* January 16, 1967; and Leslie Carpenter, "Washington Beat: A Bed Situation," *Boston Sunday Herald,* January 22, 1967.

33 Stevenson, interview. This account is also found in ibid., 121.

34 Stevenson, interview.

35 "JFK's Last Telephone Call? Mrs. Johnson Thanked for Art," *Fort Worth Press,* November 24, 1963.

36 Stevenson, interview; see also Manchester, *Death of a President,* 121.

37 Scott Grant Barker, "Suite 850," 61–62, in *Literary Fort Worth* (Fort Worth: Texas Christian University Press, 2002).

38 Ibid., 62.

39 Ibid.

40 "Memento of Fateful Nov. 22nd Cherished by Artist Owen Day," *Mid-Cities News Texan,* December 8, 1963.

41 Day, interview, n. 9.

42 Manchester, *Death of a President,* 120–21.

43 In recent years, the hotel's current owner, the Hilton Hotel chain, has embraced the property's role in American history by installing additional pictorial displays about the president and Mrs. Kennedy, offering guests printed materials about the president's visit, and educating staff members.

Oil on Canvas: Texas Art Collectors and the President's Visit to Fort Worth, November 1963 David M. Lubin

A week before the Kennedys went to Texas, a lighthearted romantic comedy called *The Wheeler Dealers* opened in movie theaters nationwide (figs. 28 and 29). All-but-forgotten today, this glossy Hollywood farce provides several windows onto the whys and wherefores of the small art exhibition mounted for President and Mrs. John F. Kennedy in suite 850 of the Hotel Texas on their fateful swing through the Lone Star State. James Garner plays the part of Henry Tyroon, a wily but lovable oilman from Texas, who jets to New York in search of Wall Street investors for a high-risk drilling operation. During the course of the film, Henry meets a trendy abstract artist and discovers the commodity value of modern art. Buying up as much of it as he can afford, he hoards expressionist paintings on the walls and floor of his New York hotel suite. In the novel from which the film was adapted, Henry's girlfriend, Molly Thatcher, sees this and sighs. Almost in itself, her rumination provides a sufficient explanation for the art exhibition provided in suite 850:

> As she considered the stack of pictures, the loneliness of the room suddenly struck her. It began with the telephone; being a hotel telephone, it had no dial, and without a dial it looked stark and bare. The furniture was duplicated in a thousand hotel rooms. Even the wastebasket had an inane pattern of flowers. The pictures on the wall were equally inane; kittens playing, a sporting print. Tyroon, Molly thought, probably spent most of his life in hotel rooms, stark, faceless rooms, where the telephones never even had any dials. No wonder he wanted the pictures! They were something permanent, something to possess in the chintz wilderness.[1]

Like Molly Thatcher, Ruth Carter Johnson (later Mrs. Stevenson) and her friends sympathized with the plight of the travelers from afar. They wanted to spare the Kennedys the tedium of stark, faceless rooms. The president, as a longtime political campaigner, must have spent countless nights in such rooms, and Mrs. Kennedy had, in redecorating the White House, struck out boldly against America's chintz wilderness. So right from the start let's agree that the exhibition of art in suite 850 was a gesture of kindness to the weary and cultured travelers from the East who would be spending the night in Fort Worth's grand hotel. It was an act of aesthetic charity. But the ad hoc display of art was, to be sure, much more than that, for it also sent out various messages of state and city pride. *The Wheeler Dealers* can help us see how.

Henry is not really from Texas. He only pretends to be, the better to capture his quarry. In truth from Boston, where he earned an Ivy League degree, he affects a Texas twang and sports western-style clothing because they help him swing his business deals. On the cab ride into Manhattan, he switches from business attire into western apparel, replacing his necktie with a string tie and pulling on a pair of cowboy boots, so that he hits Wall Street looking the part of a Texas oilman. Later in the film he is visited in his suite by three good-old-boy Texas speculators, satirically called R. Jay, Jay Ray, and JR, who are decked out in western garb, as he is.

This is not the first time we have seen grown men dressed like cowboys. Western attire then, as now, had strong symbolic associations. In the early 1960s, when the Kennedys went to Fort Worth, there was no specifically northeastern or southern or Midwestern or West Coast style of dress that marked any of these regions off from the others, but there was a distinctively western costume. Cowboy apparel signified Texas—other parts of the West, too, but Texas specifically. Like the kimono in Japan, the sari in India, the dirndl in Austria, and other instantly recognizable clothing configurations, the cowboy suit was a marker of

national, or in this case state, identity. Perhaps the term *national* applies after all. Throughout its long and tumultuous history, the Lone Star State has often seemed to be, or wanted to be, a semiautonomous nation.

The Texas literary historian Don Graham has said that "Texans have two pasts, one made in Texas, and one made in Hollywood."[2] It is this second Texas, the one of myth and media, that stirred my imagination when I was a child growing up in the Midwest and has intrigued me ever since. Let me confess, I have much greater familiarity with Hollywood Texans than real-life Texans, though I've met some of them, too. Even they seem to have absorbed the stereotype deep into their boot-cut genes, and one cannot help but wonder whether modern-day Texans walk and talk and dress the part with something of the entrepreneurial, wheeler-dealer, self-inventing spirit that Henry Tyroon shows when switching outfits to fulfill other people's expectations.

28
Poster advertising the film *The Wheeler Dealers*, 1963

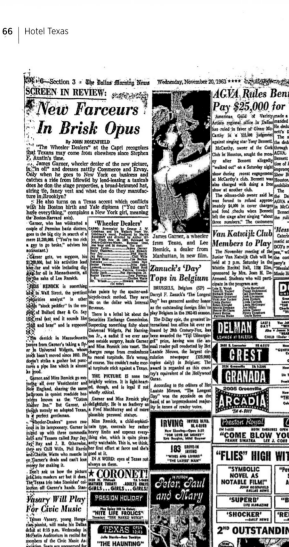
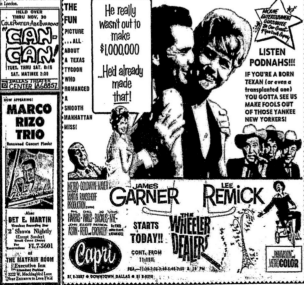

29

Review and advertisement for the film *The Wheeler Dealers* in the Dallas *Morning News,* November 20, 1963

30

Photograph of the Hotel Texas marquee, November 22, 1963, the sign welcoming the president and carrying the motto "Where the West Begins"

Texas stereotypes are at the heart of the display put on—or, as social theorists might say, performed—for the distinguished visitors from the East. Besides offering warmth and hospitality and, at the same time, getting in some private licks at neighboring Dallas, the small but impressive show in suite 850 took dead aim at the prevailing cultural stereotype of Texans as loud, boorish, swaggering money-hogs. It set out to prove that Texans could also be gracious, generous, refined sophisticates who knew a thing or two about art. Paradoxically, by trying to offset one stereotype, they played into another: that Texas millionaires, especially in the oil business, are filthy rich and can do whatever they dang well please with their money, including festoon the walls of a local hotel with the likes of Picasso, Monet, Kline, and van Gogh.

———

But let's go back to western clothing, the ranch suit in particular. No one was more important in creating the Texas business look than the media baron, real estate mogul, and Fort Worth booster-extraordinaire Amon G. Carter (1879–1955), whose relentlessly promotional vision for Texas figures into the discussion at hand. The masthead of Carter's newspaper, the *Star-Telegram,* proudly identified Fort Worth as "Where the West Begins"—a slogan that greeted the Kennedys on the hotel's marquee (fig. 30). He played

up this designation at every opportunity. A superpatriot, he believed that the American frontier, with its emphasis on self-reliance and rugged individualism, safeguarded democratic liberty, and thus the motto did more than merely advertise a city. It underscored Carter's unfailing belief in the redemptive and regenerative value of the American West.

Like Henry Tyroon, Carter sported Texas attire on his business trips outside the Lone Star State, including his friendly call on Eleanor and Franklin Roosevelt at the White House in 1939. He favored string ties, ten-gallon hats, and cowboy boots. On trips east, his biographer reports, he would sometimes startle onlookers by begging their attention and then letting rip: "HOOOOOOOOOOOOO-RAAAAAY FOR . . . FORT WORTH . . . AND . . . WESS . . . ST . . . TEXAAAAASSSSS!"[3]

This is the sort of behavior caricatured in movies such as Stanley Kubrick's black comedy *Dr. Strangelove,* released only two months after the assassination. In the surrealistic climax of the film, a Strategic Air Command bomber pilot played by the Texas character actor Slim Pickens straddles a thermonuclear device and rides it rodeo-style to its apocalyptic destination in the Soviet Union while whipping his cowboy hat against his flank and hooting and hollering "Yee-haa!" all the way down (fig. 31). In an earlier film, the classic western *Red River,* which was shown

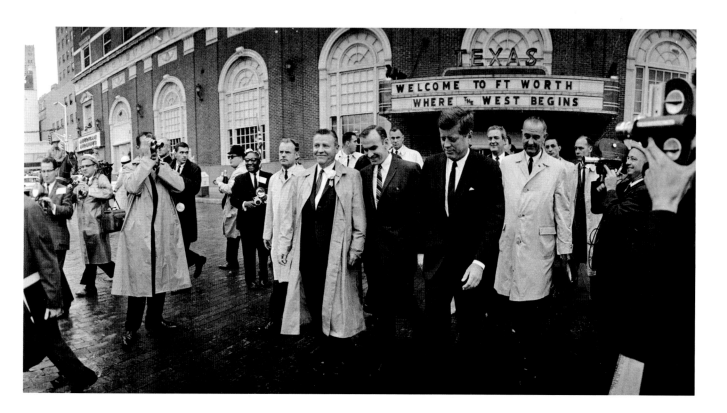

regularly on television during my childhood, a band of Texan cow-herders starting a cattle drive to Kansas emit essentially the same unearthly cry (fig. 32), which my friends and I imitated whenever we began heroic expeditions of our own or, later, wanted to make fun of the same.

The point here is that, by the early 1960s, when I was feeding at the trough of popular culture like a hungry young calf, Texas stereotypes were ubiquitous, and most Americans, even the Kennedys, I am guessing, could not have escaped them. The president enjoyed westerns, which he sometimes screened for guests in the White House, whereas his wife preferred European art cinema.[4] The self-appointed welcoming committee for the Kennedys might have chosen to suit the president's taste, replacing the generic hotel art with Indian baskets and cowboy paintings, but instead they seem to have had the First Lady's cultural predilections in mind.

No one was a bigger collector of western art than Amon Carter. He acquired it with the passion and scope of any serious art collector, but his sights were set squarely on paintings and sculptures of the Old West. In particular he favored the art of the nineteenth- and early twentieth-century masters Frederic Remington (1861–1909) and Charles Marion Russell

(1864–1926). They, indeed, were the old masters, who taught a generation of Hollywood's old masters, such as John Ford, William Wyler, and Howard Hawks, how to conjure up the Old West in a visually striking manner.

When Carter died in 1955, he bequeathed his extensive art collection to his beloved Fort Worth. Six years later, his daughter, Ruth Carter Johnson, established the Amon Carter Museum of Western Art (now the Amon Carter Museum of American Art), which today remains open to the public free of charge. From the start Johnson wanted to expand the collection to include other types of art. For her architect, she chose Philip Johnson (no relation), America's leading exponent of the International Style, who designed an elegant glass-encased building that could just as well have been erected in New York, London, Tokyo, or West Berlin (fig. 33). Nothing in the museum design shouted "Texas," let alone "yee-haa!" One imagines that Amon Carter might have preferred to house his art in a structure that resembled the Alamo. His daughter, obviously, did not share that inclination.

While proud of her Texas heritage and her father's remarkable art collection, she did not make a practice of wearing fringed leather vests. Even though she was a Republican, she must have

31
Still image from the film *Dr. Strangelove* (1964), showing Slim Pickens riding the nuclear bomb

32
Still image from the film *Red River* (1948), showing a cowboy shouting at beginning of a cattle drive

felt an affinity for Jacqueline Kennedy, another rich and power-ful woman who was gifted with aesthetic perception. Throughout America, it seems, millions of women, regardless of political affiliation, deeply admired the First Lady and wanted to act and dress and carry themselves as she did. Mrs. Kennedy epitomized the International Style, not only in her linguistic fluency, love of travel, and sophisticated literary and artistic taste, but also down to the clothes she wore: simple, elegant suits and dresses devoid of excess ornamentation. Similarly, Philip Johnson pro-vided a lofty setting for Carter's regional and historical art col-lection, eschewing regional and historical markers. This was a style that self-consciously sought to transcend national borders in art, architecture, and design—and, it might be said, in geopoliti-cal sensibilities as well, much as political moderates and liberals hoped to sidestep the bunker mentality that had marred the ear-lier years of the Cold War.

Let us recognize, then, that the choice of art for suite 850 amounted to a vote in favor of internationalism. The suite of rooms set aside for Vice President Lyndon Johnson and his wife, themselves Texans, was hung with a dozen or so western pieces from Amon Carter's personal collection, and surely the same could have been done for the Kennedy suite, given how much

there was to go around. Instead the organizers limited the west-ern art in suite 850 to two pieces, and both of these can be seen as fostering the spirit of transregionalism or peaceful coexistence. In *Sombrero with Gloves* (plate 14), the New England-born mod-ernist Marsden Hartley (1877–1943), who frequently repaired to New Mexico, fashions a small Southwestern landscape from articles of western clothing. Russell's beautiful, albeit sentimental, vignette *Lost in a Snowstorm—We Are Friends* (plate 13) shows a band of Indians on horseback providing assistance to cowboys, their nominal enemies, who have lost their way in a storm.

———

The artworks in suite 850 evoked other associations beyond those we have seen so far—that is, offering hospitality to strangers, off-setting stereotypes, and embracing cosmopolitanism. For one thing, the exhibition can be seen as extolling the liberal tax codes of the day, and *The Wheeler Dealers* shows how this was the case. When R. Jay, Jay Ray, and JR visit Henry in his Manhattan hotel suite, he surprises them by remarking that oil on canvas can be worth more than oil in the ground. That's because of its greater depletion allowance. Henry walks them through the process: "You buy the paintings, you give them to the museum, and then you

33
Amon Carter Museum of Western Art, Fort Worth, Texas, 1961

take a deduction on the appraised value, which is going up. I figure I can save you, oh, say, ten cents on the dollar off income."[5]

John Bainbridge, a *New Yorker* columnist who, in 1961, published a humorous study of wealth in Texas, tells basically the same story. The art-collecting mania found there, he writes, "is incubated in the endlessly entertaining American tax structure, which encourages millionaires to accumulate art by largely blunting what H. L. Hunt customarily calls the tax bite. If he or one of his art-minded friends buys a work of art and presents it to a museum or other tax-exempt institution, he can enter a delightful deduction on his tax return and yet retain custody of the work during his lifetime."[6] Henry Tyroon is described, in the opening pages of *The Wheeler Dealers* novel, as "one of the fastest draws in the West with a tax table."[7] His friends are intrigued by the financial prospects he dangles before them. Emerging from a huddle, they declare their intention to invest in his new "oil" enterprise, explaining, "We could buy a little culture and take it back to Texas." Although the film is set in the present, 1963, and the line satirizes cultural patronage as an afterthought to making money, the impulse to bring "a little culture" to Texas has deep and honorable roots in the state's history.

Four decades before the movie appeared and the Kennedys came to town, the Fort Worth Art Association, housed in a local public library, sought to enhance its fledgling collection of American art by purchasing *The Swimming Hole* (now called *Swimming,* plate 15) from the estate of the nineteenth-century American realist Thomas Eakins (1844–1916). In correspondence with agents for the artist's widow, the librarian, Mrs. Charles Scheuber, apologizes for being able to offer only seven hundred dollars for a painting priced at thirty-five hundred dollars:

> We want to assure you that it is not due to our lack of appreciation of the picture and its value but it is due to the extreme difficulty of procuring any considerable sum of money for pictures in this new country which has not inherited anything and whose people are engaged in the work of carving a city out of the raw prairie. . . . The museum is doing much to give our people an appreciation of art. It is a little outpost which is doing missionary work in preaching the gospel of art.[8]

In a follow-up letter to the agent, which led to the completion of the transaction, she wrote,

> I trust both Mrs. Eakins and you will appreciate our position and understand that our small offers for the pictures are not due to a lack of appreciation of their value but to the difficulty of securing any considerable sum of money for the purchase of pictures and our desire to have the Museum own one of Mr. Eakins [*sic*] representative canvases. I fear Mrs. Eakins will think we are endeavoring to enrich the Museum at her expense. I trust that the fact that by the sacrifice she is assisting to build up art appreciation in this rapidly growing city in the raw fast developing section of our country and that this little Museum which is having such a struggle is destined to be a great Museum some day, may prove some compensation.[9]

Scheuber was correct in her estimation of the painting's importance. Frequently reproduced in books and requested for art exhibitions throughout the United States and Europe, it has become one of the indisputable icons of American art. In 1990, when the Fort Worth Art Museum, renamed the Modern Art Museum of Fort Worth and looking to fund a new building, put the painting up for sale at a price of ten million dollars, a variety of local institutions and private donors successfully rallied to keep the masterpiece in the city that had long been its home.[10] Ironically, Scheuber, whose only goal had been to bring a little culture to Texas, turned out to be one of the greatest investors in the state's history.

But even in the 1960s Fort Worthians attached a great deal of pride and value to *Swimming,* and it is not surprising that the organizers of the suite 850 display would choose to hang it in the place of honor over the president's bed. As it happened, the president did not sleep in that bed, because his Secret Service detail determined that the suite's master bedroom, which had originally been designated for the First Lady, was more secure. So Thomas Eakins's bucolic depiction of five naked young men sunning themselves on a rock and diving into a countryside pool, while a middle-aged swimmer (the artist) and his Irish Setter paddle toward them, presided that night not over Jack Kennedy's dreams, but over Jackie's.

———

Swimming may have been the most famous art object in suite 850 that night, but of the sixteen artists represented by the

show, none, except perhaps Vincent van Gogh, who died in 1890, would have had greater name recognition than Pablo Picasso (1881–1973). At the time, the Spanish painter, sculptor, and printmaker, then eighty-two years old, was the world's most famous living artist. He was also, by far, the most controversial artist in the show. This was not only because of his prominent place in the history of modern art, with a style of painting and sculpting that outraged many traditionally minded Americans, but also because he was a vocal member of the French Communist Party and, in 1950, had accepted the Stalin Peace Prize from the government of the Soviet Union.

Picasso's bronze sculpture *Angry Owl* (plate 2) greeted the Kennedys in the entryway of the suite. A photograph in the *Star-Telegram* the day they arrived shows Johnson and her friend Lucile Weiner looking in through the passenger door of Johnson's car at Picasso's scowling bird (fig. 34). It has been belted into the front seat for transport from the Weiner home in suburban Fort Worth to the Hotel Texas downtown.

The photograph hints at some of the hidden meanings of the exhibition in suite 850. Before we get to what these might be, let's consider the object itself. To do that, we need to see it

in relation to a much more famous bird by Picasso, *The Dove of Peace,* which he created as a lithograph for the first meeting of the World Congress of the Advocates of Peace, held in Paris in 1949. The resulting World Peace Council, founded in 1950 with support from the Communist Party, took Picasso's elegant drawing (fig. 35) as its international emblem. The image has become a staple of modern visual culture. Constructed from a minimum of interlocking black lines in a graceful rhythm, it is the essence of simplicity, soaring purposefully against the purity of the blank page, an olive branch in its beak.

By contrast, *Angry Owl* is short, squat, and compact; it resembles a mortar shell or some other warlike projectile. This owl does anything but soar. It is more closely related to Picasso's earth-bound bulls than to his ethereal birds. Historically, owls have always been invested with dual symbolic meanings. They have long served as avatars of wisdom and intelligence but also have been feared as omens of doom and destruction. In 1950 and 1951, Picasso produced a series of owl sculptures in ceramic and bronze versions, the latter incorporating found objects, such as small pieces of hardware. Some of these owls appear to be angry; others do not. It was certainly a time of anger for the artist. In

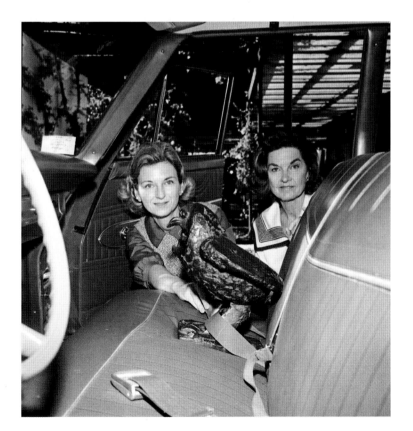

34

Ruth Carter Johnson and Lucile Weiner with *Angry Owl* by Pablo Picasso

January 1951 he painted *Massacre in Korea* (fig. 36), which depicts robotlike soldiers in riot gear pointing their weapons at a group of unarmed, unclothed women and children.

In 1956 Picasso had been the focus of a censorship controversy in Dallas. When the Dallas Public Library unveiled a small exhibition of modern art, complaints immediately poured in about the library's showcasing the work of an avowed communist. The offending objects—a painting and a rug—were hastily removed. In response, John Rosenfeld, an art columnist for the Dallas *Morning News*, commented sarcastically: "This would be as good a time as any for our fair city to arrive at a clear and simple code to govern the exhibition of paintings, the performance of music and drama, the circulation of books, or any other expression of mankind's creative spirit or mental processes. This should be: If anybody objects, yank it down or ban it from the halls or burn it up." If the Venus de Milo were to be exhibited, he speculated, local guardians of morality would insist she wear a bra.[11]

A second and concurrent controversy developed in Dallas in 1956 over the public display of art by American artists who, though not communists themselves, had lent their names to organizations accused of being Communist Party fronts. The trustees of the Dallas Museum of Fine Arts, responding to this pressure, stood on higher ground. They announced that the museum's policy was "to exhibit and acquire works of art only on the basis of their merit as works of art." The Dallas *Morning News* boiled this down in a headline: MUSEUM SAYS REDS CAN STAY. At a packed meeting of concerned citizens at the Highland Park Town Hall, the president of the Patriotic Council, a local organization that objected to the display of art by communists, urged attendees to join her in ensuring that "our Dallas is a citadel of safety against these insidious threats." At a time when Senator Joseph McCarthy and his extremist views had been discredited across much of the nation, sentiments such as these, reported in the national media, gave Dallas notoriety as a throwback to an earlier era.

35
Pablo Picasso, *The Dove of Peace,* c. 1950. Pastel, 9 × 12 ¼ inches. Musée d'Art Moderne de la Ville de Paris, Paris

In 1958, some of the more liberal citizens of Dallas tried to make amends. That year, the Weiners' *Angry Owl* was displayed at the recently opened Dallas Museum for Contemporary Arts in an exhibition called *From Rodin to Lipchitz.* Perhaps in an effort to forestall new complaints about showing art by Picasso and other communists in public, a page in the exhibition was devoted to a paean to private property (fig. 37). Titled "The Joys of Ownership," the piece included the comment that "the basic joy of ownership is that it represents one of the purest bonds between two individuals—the sculptor and the owner. From one is the idea, perception and execution. From the other, recognition and appreciation."[12] This seems a rather innocuous attempt at rehabilitation. The underlying message appears to be that it does not matter that the maker of a work of art is a communist, as long as the owner is a capitalist.

Surely the *Star-Telegram*'s photograph of two Fort Worth women with Picasso's owl constitutes an ode to the joys of ownership. More than that, though, it was also an act of defiance against neighboring Dallas. That is to say, the women may have been giving Dallas "the bird" (a phrase—and a practice—of medieval origins). Ruth Carter Johnson's husband at the time, Lee Johnson, was the executive editor of the *Star-Telegram,* her brother, Amon G. Carter Jr., published it, and her father, Amon Carter Sr., had made it into the formidable press enterprise that it was. The elder Carter was well known for his dislike of Dallas. It was said that whenever he had to go to Dallas on business, he packed a lunch because he thought the restaurants there were so bad—or, as other versions had it, because he did not want to contribute a dime to the rival city's prosperity.

In his study of wealth in Texas, Bainbridge began by assessing the differences between Fort Worth and Dallas:

> Though only twenty-nine and six-tenths miles of new six-lane turnpike separate downtown Dallas from downtown Fort Worth, the two cities stand about as far apart in character as

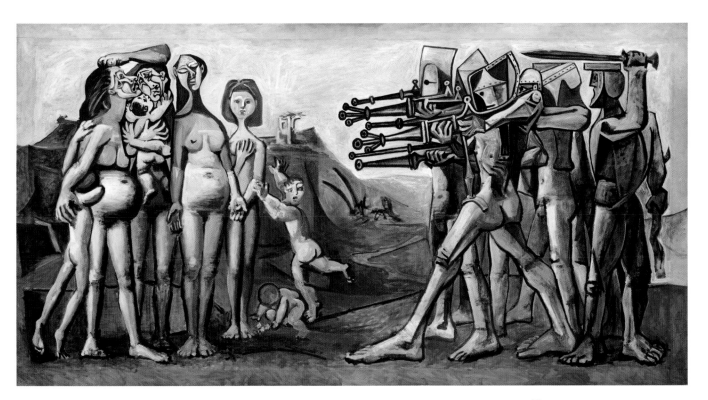

36

Pablo Picasso, *Massacre in Korea,* 1951, oil on plywood, 43¼ × 82⅝ inches. Musée National Picasso, Paris

the city mouse and the country mouse. According to the masthead of the Fort Worth *Star-Telegram*—the larger of two newspapers in a city of approximately four hundred thousand—Fort Worth is "Where the West Begins" (Dallas, according to the old saw, is "Where the East Peters Out"), and a visitor soon encounters enough phenomena popularly associated with the West to make him think that the motto holds the truth. For one thing, genuine cowboys, something of a rarity in Dallas or anywhere else in East Texas, suddenly become a common sight. In the old days around Fort Worth, they used to say the cowboy was king; there is evidence that he has not yet really been deposed. A noticeably large share of the people in the hotel lobbies are cattlemen, easily identifiable by their ranch suits and wide-brimmed hats. Many of them have been making business trips to Fort Worth for twenty years or more without once going over to take a look at Dallas.[13]

Bainbridge writes of Fort Worth's most famous citizen, Carter, who in his prime had entertained industrialists, actors, admirals, generals, and United States presidents at his ranch:

"To let his guests know they had reached the place where the West begins, Carter liked to summon them to a meal by mounting his palomino and galloping at high speed around the premises, meanwhile letting go with a pair of six-shooters." He adds, "Any advance for Fort Worth, especially the attraction of new industry, elated Carter, but the triumph was sweeter if it was gained at the expense of Dallas." Wives of men wishing to curry favor with Carter were said to remove labels from clothes surreptitiously purchased at Neiman-Marcus and replace them with labels from a Fort Worth store. In 1936, when Fort Worth lost out to Dallas as the site for the Texas Centennial celebration, Carter hosted a rival celebration, Frontier Centennial, which he advertised with the slogan "Go to Dallas for Education, Come to Fort Worth for Entertainment." Bainbridge calls this "inspired nose-thumbing."[14]

And so, too, perhaps, was the *Star-Telegram*'s decision to run a photograph of Amon Carter's daughter loading up a Picasso in the front seat of her car for exclusive viewing by the first couple.

It did not matter that the Carters and their friends were devout Republicans; they were sending a message, by way of the photograph, that they were not the kinds of people who would renounce art by an artist whose politics differed from theirs. Nor would they fail to follow in Amon Carter's footsteps and provide the best possible welcome to visiting dignitaries, regardless of political affiliation.

Bainbridge tells the story of "one of the most discerning art patrons in Fort Worth," who was "joshed" by a friend from Dallas for collecting Picassos. "Those paintings make you a communist, the way some of our local patriots see it," the friend warned. "If you come over to Dallas, they'll have your scalp." The collector replied, "You can tell those sons of bitches over there that I've made a quarter of a million dollars on these paintings so far. That will shut them up, because that's the kind of language they understand."[15]

It takes neither a communist nor a capitalist to acknowledge that in displaying Texas-owned art, the exhibition in suite 850 also displayed Texas-made money. The West Texas news business accounted for five of the works in the show and the oil industry most of the rest. As for the remaining items, one came by way of local banking and the other two from the richly endowed Fort Worth Art Association, no longer the financially strapped entity it had been in the days when it was "a little outpost which is doing missionary work in preaching the gospel of art." Both these institutions benefited directly from the abundance of crude oil lying beneath the soil of West Texas. Fort Worth profited from the beef and aeronautics industries as well, but clearly oil money was at the core of the intimate art show put on for the Kennedys.

Beside a photograph of one of the organizers admiring the art, the evening edition of the *Star-Telegram* for November 21, 1963, included an article titled "Fort Worth Awaiting Arrival Of Kennedy Party Tonight" (fig. 38). The page in its entirety seems peppered with unintended ironies. Not the least of these is the headline of a second article: "Presidential Suite Placed Under

37

Photographs of a page in and the cover of the pamphlet accompanying the exhibition *From Rodin to Lipchitz,* Dallas Museum for Contemporary Arts, 1958

CHOICE ART . . . Sam Cantey III inspects Monet painting

—Star-Telegram Photo

Art Works Installed

Presidential Suite Placed Under Strict Secret Service Vigilance

Suite 850 at Hotel Texas was "secured" shortly before 11 a. m. Thursday and will not be entered again until President and Mrs. Kennedy arrive shortly before midnight for an overnight stay.

Secret Service vigilance will be maintained until the presidential and vice presidential party leaves the hotel at 10:30 a. m. Friday.

Sam Cantey III, executive vice president of the Fort Worth Art Association, Mrs. J. Lee Johnson III, an association vice president, and Mitchell Wilder, director of the Amon Carter Museum of Western Art, were among the last to leave the suite before it was sealed.

They directed workmen in hanging a choice selection of work by great artists installed for the appreciation of Kennedy and, particularly, the First Lady.

MONET'S PORTRAIT of his granddaughter, seated and holding a large doll, was hung at a focal point in the living room of the Chinese modern suite.

The oil is owned by Catherine Lehane Johnson, 10-year-old daughter of Mr. and Mrs. Johnson. It was a gift from her grandmother, Mrs. Burton Carter.

A Van Gogh was placed over the double headboard for the twin beds that will be occupied by the Kennedys. It is of the late Paris period and is entitled "Road with Peasant Shouldering a Spade."

Mrs. Johnson explained Thursday that works of Texas artists were not used for the presidential stay because the Lone Star State has so many fine artists the practical limits of space precluded that.

SHE ALSO NOTED there will be no reproductions in the Will Rogers Suite to be occupied by the Johnsons.

Russell water colors from the Carter museum have been hung in that suite.

A selection from Cantey's collection, "Sea and Rocks" by John Marin, was hung in the suite's smaller bedroom.

It will be occupied by a presidential attendant.

Mrs. Iva Estes, executive housekeeper at the hotel, ordered a new blue nylon bedspread made up for the master bedroom.

Walls in that room are beige while the living room and smaller bedroom are a vivid blue.

Waiters stocked the suite's cocktail bar which opens into the living room, shortly before the suite was secured.

THEY TOOK IN SCOTCH WHISKY, soda and a variety of soft drinks.

Mrs. Estes who has had the light gold-colored carpeting in the suite's living room cleaned several times in the past few days, had the floor covered with sheets and asked workmen and others to remove their shoes.

The carpeting had been smudged repeatedly in recent days by Secret Service agents, hotel employes and newspaper and TV representatives.

Only White House telephones are in the suite. They are controlled by a special switchboard installed in the hotel. The Kennedys do not want outgoing or incoming local calls.

Governor To Be TMA Speaker

HOUSTON, Nov. 21 (AP)—Gov. John Connally was to address The Texas Manufacturers Association's 41st conference here Thursday.

Other speakers during the two-day session include Dr. John E. Hodges, vice president and general manager, Hughes Dynamics, Inc., Los Angeles; F. G. Rodgers, vice president, International Business Machines Corporation, Los Angeles; and Felix N. Williams, vice president, Monsanto Chemical Company, St. Louis.

Directors of the association Wednesday named A. R. Watson of Amarillo as its 1964 president.

Other officers named include William T. Green, Fort Worth, statewide vice president, and D. D. Warren, Houston, treasurer.

Computer Has Plenty Of Skill at Checkers

From Page 1

thinking by using machines to mimic the brain.

The human brain is an immensely complex mechanism, so complex that many scientists don't believe man can build a model of it. Dr. Samuel doesn't think it's necessary.

"FOR YEARS, MAN tried to fly by trying to build a machine fashioned after the bird. Then it was discovered that you don't have to copy a bird to fly. You study the principles involved in flight and then use that knowledge to build your own machine."

To simulate human thinking, Dr. Samuel believes the trick is to understand what the brain goes through in learning something, then get a machine to do the same thing.

Dr. Samuel chose checkers for trying to determine what is

worked well enough to beat champion Nealey last year at checkers.

But does the machine actually learn? Dr. Samuel said it does profit from experience. Does he feed rules into the machine so that it does?

"I tell the machine things like, 'You'd better count the pieces,' but I let it find out for itself whether it should have more. It also finds out for itself things like whether the one and three piece should be retained."

NEALEY AND THE machine play checkers by mail, each describing to the other what move he—or it—wants to make. The machine, Dr. Samuel said, makes its moves in one minute.

Actually, Nealy and the machine are playing six games simultaneously. As of last week, no game had been completed.

The Connecticut checker champ may not have a chance.

Fort Worth Awaiting Arrival Of Kennedy Party Tonight

From Page 1

serve a capacity of 2,000 persons at the breakfast.

"Welcome Mr. President" went up on the marquee this Wednesday and 1,200 places already had been set up for the breakfast.

Linen and dishes were in place all over the ballroom, but one section, seating 300, will be in use Thursday for the Metropolitan Dinner Club meeting.

After the dinner, a crew will be kept on to clear those tables and reset them during the night.

"We are completely ready and I can visualize a very smooth operation," said Pete Saccu, hotel catering manager.

"The Chamber of Commerce is so well organized it has made the job very easy," Saccu added.

In place back of the President's chair at the head table was a message from the chamber, which is sponsoring the affair.

Red letters, sprinkled with white glitter, spelled out this message.

"Members of the Fort Worth Chamber of Commerce must be missionaries of progress, not just beneficiaries of the efforts of others."

Space is so limited in the ballroom, only about 30 members of the Texas Boys Choir will perform from a small platform that has been placed to the right of the head table. Others will stand on the floor.

A band will stand, single file, against one ballroom wall and play "Hail to the Chief" as the presidential party enters.

A press table, for about 80 correspondents, will be in a roped-off area to the left in the ballroom.

Two rooms on the mezzanine floor, the Santa Gertrudis and Hereford, will serve as press rooms and have been equipped with telephones and teletypes.

The Star-Telegram has set up a separate press room for use by its 19 reporters and photographers recording the presidential visit for afternoon and morning editions.

Fort Worth public schools will not be closed for the presidential visit, school administrators stated Thursday, and absentees on Friday will be handled in the usual manner.

However, at Castleberry High School, 215 Churchill Rd., students and teachers will walk to State Highway 183 to see the presidential party drive by in a 16-car motorcade.

The high school band will serenade the President.

This will be after the motorcade leaves the hotel at 10:30 a. m. The President's plane is to depart from Carswell at 11:15 a. m.

The 2nd Air Force Band from Barksdale Air Force Base in Shreveport will play at the airbase.

The Texas Christian University Band is scheduled to play at the hotel, perhaps in the lobby.

There is no plan to cancel the appearance of the President on the parking lot in event of rain, according to Raymond E. Buck, chamber president.

The hotel arranged to have a speaker's platform erected on the lot.

A security session was to be held Thursday with Secret Service agents and representatives of the Fort Worth police department, the sheriff's office and Carswell attending.

Fort Worth police will be at Carswell Air Force Base from 45 minutes to one hour before the President's plane is scheduled to land, Assistant Chief Roland Howerton said Thursday.

Howerton could not say how many off-duty policemen and plainclothesmen would be employed to guard the President's landing, although he did say there would be more uniformed policemen than plainclothesmen.

Howerton met with other city officials Thursday morning to discuss plans for the Thursday night arrival.

From here, Kennedy will go to Dallas for a luncheon at the Trade Mart and from there he will fly to Austin for a $100-a-plate Democratic fund-raising dinner Friday night.

The President and Mrs. Kennedy will spend Friday night with the Johnsons at the LBJ Ranch near Austin and plan to return to Washington Saturday.

Although the White House has labeled the trip "nonpolitical," Kennedy comes to Texas in a highly political atmosphere and reportedly to see for himself the effects of the Democratic Party split.

JFK Plans Birthday Phone Call to Garner

WASHINGTON, Nov. 21 (AP)—President Kennedy plans to telephone personal congratulations to former Vice President John N. Garner, who is observing his 95th birthday at his home in Uvalde, Texas, Friday.

A White House spokesman said Kennedy, who will be in Texas on a three-day tour, will make a special phone call to congratulate Garner on the anniversary.

Garner was Vice President under Franklin D. Roosevelt from 1933 to 1941.

Cash Treasury Balance

The cash treasury balance Nov. 18 was $5,712,929,109, compared with $6,343,888,956 a year ago.

Booklets On Child Available

Reprints are now available in booklet form of "The Scatter Child" series by Star-Telegram Science Writer Blair Justice.

The six-feature series concerns children who have perceptual difficulties which give them trouble in school. Some of them do not read well, yet have IQs of 130 along with remarkable vocabularies.

The complete series discusses the problems and the search for the solutions.

Only a limited number of the reprints is available, therefore may be filled in order to distribute them equitably. There is no charge but please enclose five cents postage for each booklet, addressing your request to the Star-Telegram's promotion department.

Boy Can Victim's Rites Set

Funeral services for Leland O'Bryant Jr., Mr. and Mrs. C. L. 4633 Quails Lane, will 11:30 a. m. Saturday. Brumley Chapel, wi place to be announced

The youth died of the eye en route to Wednesday night.

He was born in T Ala., with a tumor eye. Doctors removed to save his life.

Seventy X-ray were given him right was removed in Octo he had entered a six class at Lily B. Cla mentary School.

He spent his last home with his family, cludes a sister, Barbar Other survivors are parents, Mr. and Moses of Texarkana.

Highway Work in Waxahac Area Boosted by Tarrant Jud

Star-Telegram Austin Bureau
AUSTIN, Nov. 21 — Tarrant County Judge Marvin B. Simpson Jr. told Texas highway commissioners here Wednesday that Fort Worth and Tarrant County were hopeful of quick approval of a twin construction program on U. S. Highway 287 in the Waxahachie area.

He explained that approval of the request, estimated to cost more than $6,000,000, might produce a speedup in plans to relocate Highway 287 for a tie-in with the Poly Freeway and Southeast Loop 820.

C. H. Fleming, board chairman of Equitable Savings Association, was spokesman for the Fort Worth Chamber of Commerce's four-man delegation.

John W. Arden, chairman of the Waxahachie Chamber of Commerce highway committee, was spokesman for the Ellis County delegation.

The two-phase program for Highway 287 calls for relocating the route from near Midlothian around the north edge of Waxahachie's city limits to a point east of the city, and for a link to connect the existing section of 35-E southwest of munity to the propo loop of Highway 287.

Arden said the ne needed to divert tra from the downtown a carrying a peak load trucks and autos into Fort Worth area.

Strict Secret Service Vigilance"—a reminder that vigilance alone is not enough.

———

The next morning, the Kennedys arose early and began their day. Between engagements, the president phoned Ruth Carter Johnson to thank her for organizing the exhibition. The First Lady got on the phone and confessed that, on arriving late the previous evening, she had not noticed the works but now she had viewed them and was delighted by what she had seen.

At the formal breakfast held in the Grand Ballroom of the Hotel Texas, the civic leaders of Fort Worth ceremoniously presented Jack Kennedy with a ten-gallon cowboy hat. If ever there was an Amon Carter moment, this was it. Not wanting to provide ammunition for comedians, cartoonists, and political enemies, the president deftly avoided placing the hat on his head, stating that he would do so on Monday, when he was back in the Oval Office.

That day never arrived. He departed from Cowtown without trying on his cowboy hat. A couple of hours later he was dead, felled in Dallas by a former Fort Worth resident with a repeating rifle—"the gun that won the West." The art in suite 850 was quietly returned to its owners, and the walls were rehung with the anonymous generic paintings that had graced them before the president and his wife came to town. *The Wheeler Dealers* quickly disappeared from theaters, but it showed up occasionally on television, often enough to contribute its fair share to the popular mythology embodied in the word *Texas.*

1 Walter Goodman, *The Wheeler Dealers* (Garden City, N.Y.: Doubleday, 1959), 117. The film version, directed by Arthur Hiller and starring James Garner and Lee Remick, was released by Filmways Pictures, November 14, 1963.
2 Don Graham, *Cowboys and Cadillacs: How Hollywood Looks at Texas* (Austin: Texas Monthly Press, 1983), 2.
3 Jerry Flemmons, *Amon: The Texan Who Played Cowboy for America* (Lubbock: Texas Tech University Press, 1998), xxiv.
4 See, for example, Paul B. Fay Jr., *The Pleasure of His Company* (New York: Harper and Row, 1966), 173; and Benjamin C. Bradlee, *Conversations with Kennedy* (New York: Norton, 1975), 128; see also David M. Lubin, *Shooting Kennedy: JFK and the Culture of Images* (Berkeley: University of California Press, 2003), 25–26 and 291.
5 *Wheeler Dealers* (film; see note 1); transcript by author.
6 John Bainbridge, *The Super-Americans: A Picture of Life in the United States as Brought into Focus, Bigger than Life, in the Land of the Millionaires—Texas* (Garden City, N.Y.: Doubleday, 1961), 308; it should be observed that the tax code no longer permits people to maintain custody of artworks that they have donated to institutions. Sam Cantey IV kindly brought *The Super-Americans* to my attention over lunch at Lucille's in Fort Worth.
7 Goodman, *Wheeler Dealers,* 11.
8 Jenny S. Scheuber to Edward W. Redfield, February 25, 1925. *The Swimming Hole,* File 12, Correspondence 1925–39, Object Files, Amon Carter Museum of American Art.
9 Scheuber to Clarence W. Cranmer, May 6, 1925, ibid.
10 The most detailed account of *Swimming* and its history is Doreen Bolger and Sarah Cash, eds., *Thomas Eakins and the Swimming Picture* (Fort Worth, Texas: Amon Carter Museum, 1996).
11 Quoted in Bainbridge, *Super-Americans,* 310–11, and in Warren Leslie, *Dallas, Public and Private: Aspects of an American City* (New York: Grossman, 1964), 166; for an account of the Picasso controversy, see Leslie, ibid., 165–73.
12 *From Rodin to Lipchitz,* exh. pamphlet (Dallas: Dallas Museum for Contemporary Arts, 1958), 7.
13 Bainbridge, *Super-Americans,* 150.
14 Ibid., 154–55.
15 Ibid., 309.

With thanks to Scott Barker, Andrew Sears, and Phil Smith for help researching this essay and to Libby Lubin for help writing it.

38
The evening edition of the Fort Worth *Star-Telegram* published on November 21, 1963, carried two articles about the impending presidential visit, one illustrated by a photograph of two of the works that were by then installed in Hotel Texas

Swimming: Thomas Eakins, JFK, and November 22, 1963

Alexander Nemerov

Thomas Eakins's *Swimming* hung above John F. Kennedy's bed in suite 850 of the Hotel Texas on the night of November 21, 1963—or was supposed to (plate 15). Jacqueline Kennedy slept in that bed that night, the one in the suite's smaller bedroom, amid the American paintings placed there in the expectation that her husband would take the room. The president slept in the master bedroom, spending the last night of his life beneath Vincent van Gogh's *Road with Peasant Shouldering a Spade* (plate 11), another of the sixteen works from local collections chosen to adorn the suite. A photograph of the smaller bedroom taken late in the morning of November 22, after the Kennedys had left at around 10:30 but before the president was assassinated in Dallas at 12:30 that afternoon, shows *Swimming* in a simple modern frame above the humble bed intended for him (fig. 39). Kennedy and Eakins thereby missed a most fateful symmetry—Kennedy sleeping squarely beneath the picture that night—but still a meaningful connection arose between them then and there.

It would not seem likely. How could the connection be anything more than coincidental? Eakins's picture happened to be in suite 850 for a few simple reasons. Ever since it had been acquired in 1925 by the Fort Worth Art Association, it was "the finest American painting in the city," notes Scott Barker, and it deserved a place of honor in the presidential suite for that reason alone.[1] Then also it was part of a rugged and forthright national ensemble in the small bedroom, accompanied by other American pictures ranging from Marsden Hartley's still life *Sombrero with Gloves* (plate 14) to John Twachtman's *Geyser Pool, Yellowstone* (plate 12) to Charles Marion Russell's *Lost in a Snowstorm—We Are Friends* (plate 13), a picture of Indians signaling in a blizzard,

which hung near *Swimming*, above a bedside chair (fig. 39). The people who selected the works for the room, Ruth Carter Johnson (later Stevenson), Sam Cantey, the Fort Worth banker and art aficionado, and Mitchell Wilder, the director of the Amon Carter, felt the pictures made intuitive sense for the purpose at hand, and so they did. What more is there to say?

Consider another fact working against the idea of a meaningful connection. The Kennedys barely noticed the art during their few hours in suite 850, and it was Mrs. Kennedy, not JFK, who looked at it most. He may not have looked at the paintings and sculptures at all. The couple arrived at the hotel around midnight after a long day that started in Washington and took them to San Antonio and Houston. Exhausted, they went to sleep without noting the art or the accompanying exhibition catalogues, placed by Cantey on the suite's parlor coffee table. The next morning, with Kennedy giving a brief public talk outside the hotel a few minutes before nine, directly followed by a speech inside the hotel's Grand Ballroom before two thousand invited guests, the couple had still not considered the twelve paintings and four sculptures in their rooms. Eventually, once they were back in the suite for a few minutes following the ballroom speech, Jacqueline made "an astounding discovery," as the historian William Manchester puts it in his minute-by-minute chronicle of those days. She had assumed the works were reproductions, but now she saw that she and her husband "were surrounded by a priceless art exhibition." Even then, the discovery made, JFK did not look at the art but only consulted the catalogue to find out who created the exhibition so that Johnson, the primary organizer, could be thanked. Manchester, recounting the episode, does not

39
Installation photograph: (*left*)
Thomas Eakins, *Swimming,*
1885, and (*right*) Charles Marion
Russell, *Lost in a Snowstorm—We
Are Friends,* 1888

mention the Eakins picture, putting it merely among the "twelve other celebrated oil paintings, water colors, and bronzes" he notes generically alongside "a Monet, a Picasso, a van Gogh, [and] a Prendergast."[2] The closest Kennedy got to Eakins's painting was on the morning of November 22, when he looked out of a window a few feet from the picture. Through that window Kennedy saw, eight floors below, a "parking lot bordered by two loan companies, two bus stations, a garage, [and] a theater." The parking lot was full of people there that morning to hear him speak. "Gosh, look at the crowd!" he said to Jackie. "Just look! Isn't that terrific?"[3] The Eakins painting was all but next to him as he spoke, but what was terrific was not the picture but the scene on the streets below. It left no special mark.

Yet still there was a meaningful connection in that hotel suite between Kennedy and *Swimming.* The connection concerns a phrase we use sometimes about works of art—that they are ahead of their time. Partly the phrase concerns work too difficult, advanced, or risqué to be appreciated in the artist's era—a venerable story of art making that *Swimming* exemplifies in some respects[4]—but in that hotel suite in 1963 the painting was ahead of its time in a more profound sense.

From the moment they are completed, works of art go forward in time, gathering associations from the different places and eras in which they find themselves. All the paintings and sculptures in the Kennedys' suite, by that reckoning, resonate with the events of November 22, 1963. Van Gogh's *Road with Peasant Shouldering a Spade* achieves an extraordinary intensity for having been the picture Kennedy slept beneath the last night of his life. The fact that the painting was so artistically advanced for its era is only incidental to this stranger way that it turned out to be ahead of its time. But *Swimming* is the only one of the works of art in the suite to *acknowledge* that it will be part of a future it cannot know.

How so? The lake Eakins portrays had been created only in 1873, as Elizabeth Johns and Sarah Cash have noted, when a local mill-owner had dammed Mill Creek, flooding a meadow.[5] Eakins's swimmers lounge and stand on a ruined eighteenth-century mill foundation recognizable from photographs of the site.[6] Swimming in waters only recently made, the men trawl above the grassy floor where a few years earlier a rustic swain might have clasped the hand of his girl as the two of them, glancing around, thought the whole scene, from earth clods to speckled evening stars, from fragrant dung to chirruping crickets, would never change any more than their love. But Eakins's painting knows better.

It shows a place between times, across times. The painting is a palimpsest of before and after, of what will be and what has happened. It knows that the surety of a solid situation comes and goes. By that token, the painting knows that it, too—like the scene it shows—is a thing in time, going into some future it cannot foresee. The builder of the mill foundation could never have guessed that naked men would leap from that platform of stones. Eakins, likewise, could never know what people in the future would make of his picture. But, unlike the mill builder, he knew that the same object changes over time—he has made for us a whole picture depicting this fact—and in this sense he acknowledges that his own art will itself be adapted to situations he cannot foresee. This lucidity of the painting is rare. It can imagine futures—maybe even deeply salient ones—in which it will crystallize, come clear, in a way it never would have done before. It will take on uses and meanings for which it will seem perfectly well suited, and it will do so without ever changing a detail of what it was when it was first made. By the law that lets a mill foundation be a diving platform, the painting says that things remain the same, and change utterly, when they find their place in a future they cannot know. In that hotel suite on November 22, 1963, Eakins's picture took shape in at least three ways.

Swimming and the Memory of War

A first connection is the relation of the painting to Kennedy's experience in the Second World War. Robert J. Donovan's book *PT 109: John F. Kennedy in World War II,* published in 1961, includes a photograph of Donovan, swimming in the South Pacific (fig. 40), that strikingly evokes Eakins's painting (fig. 41). Donovan, photographed by Elliott Erwitt, follows the route taken by the young JFK, then twenty-six years old, after his PT (Motor Torpedo Boat) was rammed and half-sunk by the Japanese destroyer *Amagiri* in the Solomon Islands on the night of August 2, 1943. Kennedy and the other survivors clung to the half-submerged boat that night and for part of the next day, waiting in vain for another PT boat to rescue them, before he decided that they must all swim to shelter or risk discovery by the Japanese. Kennedy decided on

Plum Pudding Island, three and a half miles away, and set out, a strong swimmer, carrying the grievously burned crewman Patrick McMahon. (The two men were back to back, McMahon floating on top of Kennedy and kept in place by a strap from his kapok life preserver that Kennedy held in his teeth while doing the breast-stroke.) Meanwhile, the rest of the crew paddled to Plum Pudding Island using a method devised by Kennedy to keep the good and bad swimmers together: they would hold onto a two-by-eight-foot plank left floating from the boat's wreckage and kick together until they reached shore. Another photograph by Erwitt in the book, this one taken underwater, shows a group of men re-creating the improvised solution (fig. 42). The exhausted Kennedy reached the island with McMahon after about four hours, the nine men clinging to the plank soon after.[7]

The *PT 109* story and Erwitt's photographs call to mind Eakins's painting. The middle-aged Donovan moves through the water strangely like the self-portrait of Eakins half-submerged at lower right in *Swimming* (see fig. 41). The two scenes come together as more than just different moments in an American history of manly physical exercise. The first journalistic account of the *PT 109* episode, John Hersey's "Survival," published in the *New Yorker* on June 17, 1944, which details the wreck, swim, and eventual rescue of the crew, appeared a few pages before the magazine's review of the Eakins exhibition that spring and summer at the Knoedler and Company gallery in New York City.[8] Although the reviewer, Robert M. Coates, does not mention *Swimming,* the painting was included in that exhibition (and in the Eakins show that spring at the Philadelphia Museum of Art), and Eakins's depiction of "a group of youths and men swimming, diving, [and] lying on the rocks," as *Art Digest* described it in June 1944, made a pastoral counterpart to Hersey's rugged war journalism: "Then Kennedy swam from man to man, to see how they were doing. . . . But those who couldn't swim had to be towed back to the wreckage by those who could. . . . Johnson was treading water in a film of gasoline."[9]

In the early 1960s, *Swimming* matched the story of *PT 109* in another sense. It had been some twenty years since the devastating collision with the *Amagiri* in the Solomons. Thankful survivors recalled the wartime danger clearly, soberly, from the vantage of peace. Donovan's book has the quality of a reunion, with photographs of the surviving crew members, including a picture of eight of them at Kennedy's inaugural parade, and other

40
Photograph of Robert J. Donovan, the author of *PT 109: John F. Kennedy in World War II,* swimming toward Plum Pudding Island, South Pacific, 1961

41
Self-portrait in Thomas Eakins, *Swimming,* 1885; detail of plate 15

photographs of the one-time enemy, the crew of the *Amagiri,* whom Donovan interviewed and Erwitt showed kneeling, at a ceremonial dinner with the author in Tokyo in June 1961.

Eakins's painting is also peaceful yet mindful of dangers recently past. It too dates from some twenty years after a huge war. One of the main figures in *Swimming,* the diver, has long been identified as George Reynolds, a veteran and hero of the Fourth Battle of Winchester, fought on September 19, 1864, whom Eakins also depicted in a portrait of about 1885 called simply *The Veteran* (fig. 43). The recollection of war haunts *Swimming,* making it far from only a peacetime idyll, as the art historian Whitney Davis notes: "The mood of [*Swimming*] is not, as commentators suppose, a delightful innocence. . . . The finished painting is not an image of boys, all in fun, imitating the ambitions and struggles of men. Instead it is a fantasy of men setting aside care to become, once more, like carefree boys. . . . For this group, the fresh air of the pond is fresh precisely because there is no smell of death."[10] Davis likens the painting's mood to the elegiac gratefulness accompanying the veterans' memorial ceremonies of the 1880s, such as the one held at Gettysburg by the veterans of the Ninth New York at the regiment's battlefield cenotaph: "Today we hear the trumpet of glad jubilee sounding in another year of peace. As we gather closer and feel the pulse-beat of each other's sympathy, we remember to-day, with a peculiar tenderness, the missing ones, the honored dead, the heroic men who helped make our beloved land great and true."[11]

War beheld through peace, some twenty years later: *Swimming* not only matches the mood of *PT 109* but also the way others in the late 1950s and early 1960s described scenes of military men swimming, lounging, lying naked. In that sense it is itself an image of the post–Second World War years. Howard Nemerov's poem "A Day on the Big Branch," published in 1958, describes men "stripped naked" who "bathed and dried out on the rocks," sunning themselves on the cold slippery boulders after an alcohol-fueled, all-night poker debauch. The men, including the poet, are all Second World War veterans, and

> After a time we talked about the War,
> about what we had done in the War, and how near
> some of us had been to being drowned, and burned,
> and shot, and how many people we knew
> who had been drowned, or burned, or shot;
> and would it have been better to have died in the War,
> the peaceful old War, where we were young?[12]

Ultimately they accept their "mineral peace" amid the stones, affirming their right to hedonism notwithstanding the sober sight of all the damage the raging stream can do. Eakins's picture, likewise, is "a paradise tinged with inexplicable regret."[13]

Consider also James Dickey's poem "On the Coosawattee," from his collection *Helmets,* published on the first day of 1964. Dickey, another Second World War veteran, tells of two men canoeing down a river in Georgia, their journey a voyage from innocence to experience. First they are one with the fir boughs

42

Underwater photograph showing a re-enactment of the method used by Kennedy's crew to swim ashore, Solomon Islands, South Pacific, 1961

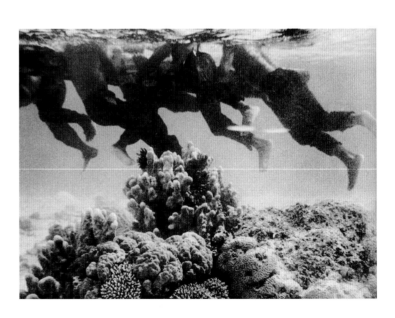

reflected on the rippling water, the angelic presence of the forest. Then they move past a chicken-processing plant, where a slime of feathers coats the rocks and a staring chicken head floats by. Last they come to rapids, where pounding water slams them against a boulder, breaks their paddles and then the canoe, and they are carried away, floating in their life preservers down to the calm water. The men crawl ashore and fall asleep "on a vast, gentle stone" until found by a country boy who, leading them away to safety, seemed "the accepting spirit of the place." All this is told in recollection: the Coosawattee, we learn, has since been dammed, the rapids become part of a lake, the boulder where the men struggled for their lives now submerged. Dickey, whom Joyce Carol Oates described as "a Whitman subdued, no longer innocent, baptized by American violence," portrays a world of water and stone much as Eakins did: as the space of comrades who lived to tell, a fable of "the yet-to-be-drowned."[14]

Eakins's bathers also recall one of the primal scenes in Joseph Heller's Second World War novel *Catch-22,* published in 1961: the fate of Kid Sampson, who one day out on the water, near the beach by the Italian airfield where the American air crews are stationed, thinks nothing of leaping up from his bobbing raft to swat the B-25 that's flying low—too low—directly over the water in a prank, an existentialist gesture of the kind that fill the book and that, here, takes a terrible turn: "at the exact moment [the moment when Sampson jumps up] some arbitrary gust of wind or minor miscalculation . . . dropped the speeding plane down just low enough for a propeller to slice him half away," so that "there was the briefest, softest *tsst!*" and "then there were just Kid Sampson's two pale, skinny legs, still joined by strings somehow at the bloody truncated hips, standing stock-still on the raft for what seemed a full minute or two before they toppled over backward into the water finally with a faint, echoing splash. . . ." All the other bathers in the water, panicking, screaming, "were struggling to get out, forgetting in their haste to swim."[15] Eakins's picture is not a primal scene but it is macabre in its own way. His robustly living figures—Jesse Godley standing proudly atop the mill foundation, for example (fig. 44)—show evidence of the hours of dissection Eakins felt it took to portray the human body. He had a "gothic imagination," as the art historian Sarah Burns notes, and an atmosphere of dissection haunts his works even though they do not literally show dissections.[16] Heller and Eakins

43
Thomas Eakins, *The Veteran (Portrait of George Reynolds*), c. 1885. Oil on canvas, 22 ¼ × 15 inches. Yale University Art Gallery, bequest of Stephen Carlton Clark, B.A., 1903 1961.18.20

both portrayed bodies anatomically, with violence and peace, and in that way, too, the painting in the Kennedys' suite was right as a recollection, in the early 1960s, of the Second World War. Fittingly, it evokes a wartime picture reproduced in Donovan's book (fig. 45)—a photograph of young Lieutenant Kennedy and his crew taken before the disaster and then seen long after it, when the book was published: we were all young once, and some of us are no longer here.

In 1963 there was a way to deny the violence, however, and that also is part of the painting's relation to JFK's war experience. The denial took the following form: the painting told a simple story; it was a bit of rustic Americana, and that was all. Here its title changes over the years are important. The picture was called *Swimming Hole* in the exhibition catalogue in the Kennedys' suite, a variation on *The Swimming Hole* (in a 1917 retrospective) and *The Old Swimming Hole* (in a 1921 show). These were a far cry from *Swimming,* its original title, and *Swimmers,* its title in the 1886 Louisville exhibition.[17] The phrase "swimming hole" implies a folksy down-home rustic wisdom and narrative clarity— counter to the picture's obscure melancholy. In Manchester's *Death of a President,* Mrs. Kennedy's realization about the art— "Isn't this sweet, Jack?"—comes at the moment that Kennedy hangs up the phone, having called Uvalde, Texas, to wish Franklin Delano Roosevelt's vice president, John Nance Garner, a happy ninety-fifth birthday.[18] Garner's "childhood years" growing up in Texas in the 1870s and 1880s were, we learn in a biography, "pleasant with the swimming holes, fishing streams and turkey and wild-game coverts in the pecan groves, and the wandering through the country with a bobtailed dog named Rover."[19] If it signified at all in suite 850 that morning, Eakins's painting might have come across as only a bit of charming American folk life, a piece of the simple times of yore. The figure of Jesse Godley monumentally atop the ruined mill foundation, his arms akimbo and his slender shoulders stuck back, has just enough of comic-book caricature, exaggerated profile, and cockiness to be the basis for Norman Rockwell's swimming hole miscreants, those insouciant kids of the crick.

But *Swimming*—the title the painting has reacquired in the past twenty years—tells no such stories. The figures betray a disconcerting atomization: their lack of relation to one another, each in his separate world, results not only from Eakins's unsuccessful attempt to combine individual figure studies into one

44
The standing man (Jesse Godley) in Thomas Eakins, *Swimming,* 1885; detail of plate 15

composition, but also from his wish to defeat the narrative clarity he probably knew would convert his picture into an anecdotal image without any spell of the strange.

The contrast between *Swimming* and *The Swimming Hole* is like the contrast between the youthful Kennedy's harrowing experience in the water and the narrative legend that grew up around it. *PT 109* provides an American folk story recounting the grim situation of Kennedy and his men, right up to and including their rescue, all the way to the crew's reunion with their commander as they passed the presidential box at the 1961 inaugural parade. The morals and meanings are all set and clear. But back in 1943, heading out at night alone from Plum Pudding Island, Kennedy swam in a more existential sense. Looking for help for his exhausted and hungry men, he "struck out into open water," wrote Hersey. "He swam about an hour. . . . He stopped trying to swim. . . . Darkness and time took the place of a mind in his skull."

Hersey is himself a storyteller—he makes a legend—but the heart of the tale is a random event that cannot be described, that has no meaning or moral, a catastrophe that is the inverse of written language. It is, like the *Amagiri*'s "peculiar, raked,

inverted-Y stack," which was visible in the explosion of the collision and "stood out . . . in Kennedy's memory, a sign of the inexplicable sudden event that had just befallen him."[20] So it would be on November 22, 1963. The assassination is part of American lore, but the trauma turned each principal figure, each bystander, too, into a figure of isolation, independent of any story, each person caught in the radically private experience of being killed or watching someone be killed. Each was a swimmer surrounded only by the froth of his own movement, a wake of changing effects, an enclosed world of inverted reflections.

The Truth

A second connection between Kennedy and Eakins's painting: *Swimming* weirdly relates to the film made by Abraham Zapruder at Dealey Plaza, in Dallas. Eakins was interested in how to depict motion, and his paintings anticipate movies. Aided by the work of Eadweard Muybridge, the celebrated pioneer of motion photography he had helped bring to the University of Pennsylvania in 1883, Eakins tried hard to show movement in his art. The critic Arthur

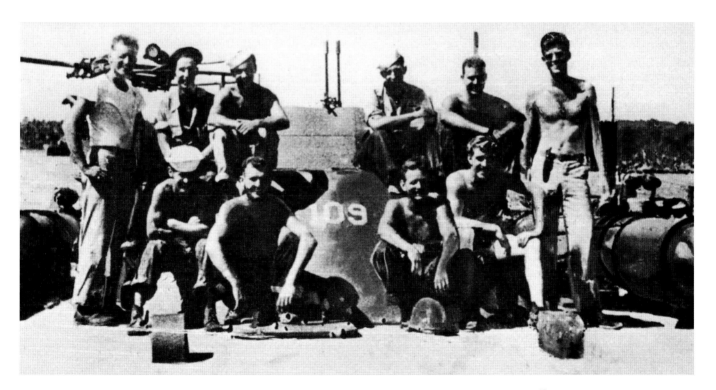

45
Lt. (jg) John F. Kennedy
(*standing, far right*) **and the crew**
of *PT 109,* **Solomon Islands, 1943**

Danto wrote in 1995 that Eakins's use of photography "ironically contributed to the progress of a technology that would undermine the verisimilitude in painting." For Danto, Eakins's use of motion photographs "as a means to further artistic fidelity" hastened the advent of moving pictures and the demise of painting as an accurate depiction of phenomena. Putting the same matter more sanguinely, the art historians William Homer and John Talbot wrote in 1963 that, "if Eakins had continued his photographic experiments, he, instead of Marey or Edison, might conceivably have become the father of the motion picture process."[21] The implied sequence in Eakins's painting—from swimming to climbing out of the water to lounging on the rocks, then gesturing, standing, and diving—happens to anticipate the frame-by-frame movements that show the death of the president who woke near the picture the day he was killed.[22]

Swimming relates to the Zapruder film in a more complex way, too. Eakins's paintings awkwardly try to combine seeing and knowing, as the art historian Michael Leja notes. They aspire to a truth of optical phenomena, but they also recognize that visual data are often confusing and unclear. Consequently, Leja points out, Eakins took liberties with appearances to "enhance narration and convey information," for example showing, in *The Champion Single Sculls (Max Schmitt in a Single Scull)*, the splash marks of a rower's oars long after those marks would have dissipated in the rower's wake (fig. 46). Without a long track of these implausibly sustained turbulent pools, the viewer could

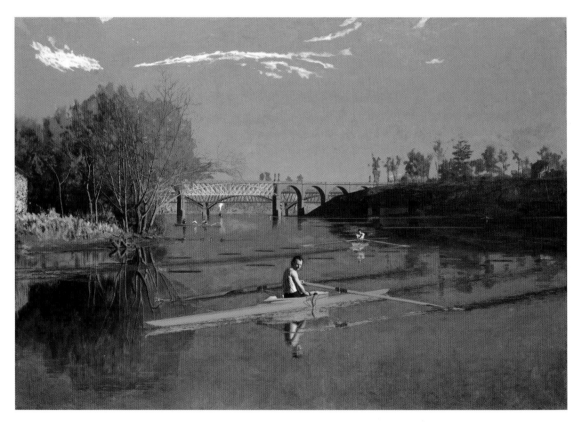

46

Thomas Eakins, *The Champion Single Sculls (Max Schmitt in a Single Scull)*, 1871. Oil on canvas, 32¼ × 46¼ inches. The Metropolitan Museum of Art, New York, Purchase, The Alfred N. Punnett Endowment Fund and George D. Pratt Gift, 1934, 34.92

not determine from which way the rower had come, so Eakins included them. The result of this mix of seeing and knowing, for Leja, is a dissonant art—one that marks a "rift opening between what is and what appears, between the truths of scientific knowledge systems and the ambiguities or deceptions of perceptual experience."[23]

The diver in *Swimming* is a case in point (fig. 47). The figure of George Reynolds should make a big splash, his head hitting the water, but "the water surface remains strangely unperturbed," writes Leja. "Only a few squirts of water, pictured as delicate white lines, shoot from the surface."[24] The diver, meant to be a ne plus ultra of the painting's realism, is in fact its least convincing figure. "The attitude of the diver is presumably correct, but it does not convey the impression of any possible motion," a reviewer noted in 1885.[25] The diver is strangely still, a frozen sign of motion held and posed in the air instead of slicing through space, and it is not surprising to learn that Eakins used a little wax model for this man, or that, according to a student, he "put a spindle through the middle of the figure so that it could be turned upside-down and hold the pose."[26] What is "presumably correct" looks wrong.

The home movie made by Zapruder at Dealey Plaza, by contrast, trusts all to perception. Unfolding events without artistry, without any schematic impositions of how the action should look, Zapruder's film streams raw data allowing analysts of the assassination to see what they need to see. For them, appearances are never deceiving, and no rift opens between untrustworthy perception and factual data. Eakins's diver, on the contrary, is a weirdly unbelievable figure of violence. There in a scene with its rising grassy background, its dark horizontal slab, and its staccato dispersal of figures engaged in separate frozen attitudes, the diver's head hits the water whereas a moment before, we understand, he has been standing proud astride the rock. Now, in a climax Leja describes as oddly undramatic, with just those few riffles of water spurting where he breaks the surface, the veteran goes under, strangely unreal and unconvincing as he does so, turning on the spindle transfixing his body. Eakins's own Zapruder film allows us to pause forever on this instant where the man disappears, snuffed out, his features having prematurely darkened and blurred as if anticipating their disappearance, his reflections elongating like a mathematical diagram of the soul.

Eakins's filmic painting helps us see the Zapruder film as itself the depiction of an unknowable phenomenon. In the

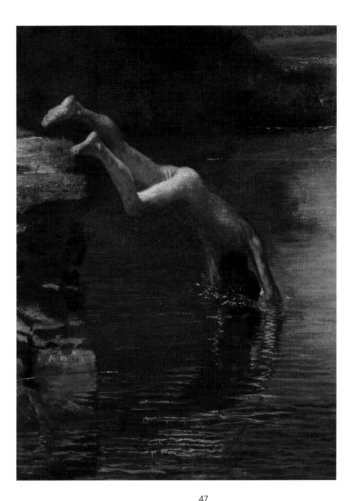

47
The diver in Thomas Eakins, *Swimming,* 1885; detail of plate 15

moments after Mr. and Mrs. Kennedy realized they were surrounded by original works of art, one of his staff members handed him a copy of that day's Dallas *Morning News,* with a full-page ad detailing a set of citizens' grievances against the president. "You know, last night would have been a hell of a night to assassinate a president," Kennedy said, grimly acknowledging the ad and referring to the chaotic throng that had greeted them in the lobby of the Hotel Texas. He motioned as if shooting a gun and then "whirled in a tense crouch."[27] Eakins's painting, dormant and unseen in those rooms, foretold the means of documenting the president's assassination two hours later—the president's great black limousine, the SS 100 X, having become, thanks to Abraham Zapruder, the most heavy and glamorous and horrible of Muybridgean sulkies. What the painting showed, however, was less the spinning wheels of a moment in time, an incontestable truth of visual perception, fateful to the last juridical fact, as viewers of the Zapruder film have often held it to be, than a moment the film holds at its own philosophical core—namely, a moment forever suspended and unbelievable, the unknowable point where a man meets his death.

Resurrection

A third point of connection between Kennedy and *Swimming* is the painting's Catholicism. The central figure in the painting, wrote the art historian Oliver Larkin in 1949, stands on the rock "with the splendid corporeality of a Signorelli figure."[28] The reference to the painter Luca Signorelli (c. 1445–1523) is one of several relating *Swimming* to Italian Renaissance art. Marc Simpson mentions the male bathers of Michelangelo's *Battle of Cascina* (c. 1504–1505), and elsewhere in the same publication we find a reproduction of Antonio Pollaiuolo's *Battle of the Nudes* (c. 1460).[29] "The fact that the figures are naked, without distracting clothes," wrote Lloyd Goodrich about Eakins's picture, "creates a plastic design whose purity and severity resemble a work of the Renaissance."[30]

Catholicism continually informs Eakins's art, and the Italian Renaissance connotation of *Swimming* is no exception. David M. Lubin wonders whether the artist's famous clinic paintings—*The Gross Clinic* (1875) and *The Agnew Clinic* (1889), with their powerful debt to seventeenth-century Spanish depictions of

48

Luca Signorelli, *Resurrection of the Flesh,* 1500–1504, fresco, Orvieto, Italy

martyrdom—are not "covertly religious tableaux purporting to be documents of scientific naturalism." He wonders, too, whether Eakins's large and ambitious *Crucifixion* (1880), which the artist always thought highly of, needs to be taken more at its religious word and not simply as a scientific study of the body.[31] Kristin Schwain, noting that Eakins grew up in a Protestant home, focuses on his "high regard for Roman Catholic prelates"—the Philadelphia seminarians and other Catholics he made so many fine portraits of—and argues for Eakins's lifelong attraction to Catholic theology and its relevance to his art.[32]

In that sense, Larkin's reference to Signorelli calls to mind the artist's famous frescoes at Orvieto, notably the *Resurrection of the Flesh,* painted between 1500 and 1504 (fig. 48). Perhaps Larkin thought of this picture rather than of its equally renowned counterparts at Orvieto, such as the *Punishment of the Damned,* because the overall effect of *Swimming,* despite the diver, is of figures rising. Perhaps he did so, too, because Eakins's separate figures recall Signorelli's working method for the *Resurrection,* which, as later scholars have noted, is "structured around numerous studies of single figures in dramatic poses," some of them emerging from the ground like one of Eakins's swimmers does at half-length from the water (fig. 49).[33] Is *Swimming* a religious painting, even a Resurrection? The idea goes against so much of what Eakins believed. Grimly dissecting corpses to study the way the body moves, digging in the troughs of the body and encouraging his students to do the same, he scoffed at the afterlife, smiling a supercilious grin when the subject came up, and he could paint in a way so mordantly tone deaf to the soul that his sitters could be forgiven for shrinking from pictures portraying them as so many neck tendons and flaring muscles.[34]

Swimming does seem forensic in the way that its critics over the years have deplored. The bodies of the men, for all their Greek nobility, seem a little too proudly anatomical—look at the calf muscles of Jesse Godley, for example. Reynolds's reflection, by the same token, is like a flayed skin of water, an anatomy of light's properties skizzing along the surface, rippled tendons and shriveled strips of light, rather than some wondrous shimmer of life and afterlife. Signorelli aside, there seems no faith here.

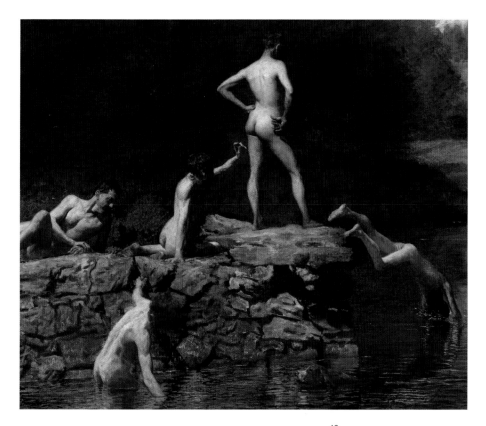

49

Bathers around mill foundation in Thomas Eakins, *Swimming,* 1885; detail of plate 15

But perhaps a religiosity shows through, in a lost and estranged but powerful form, as the painting's armature or end point—something it strives for or once had but cannot now rediscover.

The men in *Swimming* are like refugees from a painting that meant something. Isolated in their stiff gestures, they recall—as if they would make it coalesce again—a type of picture where once upon a time these same gestures, these same figures, if re-posed and tweaked and otherwise adjusted, would magically combine into a pious declamation of belief the artist wishes to find but has lost the secret of. Maybe that is why the figures appear "oddly serious" for what they are doing, as the art historian Randall Griffin has noted, why we see no "horseplay" and no "sign of glee," as we might expect of these summer bathers, who instead behave as though "involved in a sacred ritual."[35] Each man moves as if in a recollected atmosphere of solemn purpose. *Swimming* seems like the memory of a small altarpiece, a private devotional object. Sylvan Schendler wrote of the painting's "small monumental quality,"[36] and so it still hangs on a wall, any wall, like an estranged altarpiece, a religious painting that has lost its way.

If that is the case, then *Swimming* would have had its strange sanctity in suite 850. There it was, a Catholic painting portraying just the barest alphabet of benediction, a clattering array of meaningless figures, stuck among the rocks, who yet seem to remember themselves as risen souls. A little more than two hours after the Kennedys left the hotel, Father Oscar Huber, a local priest, heard the news and rushed to Parkland Memorial Hospital, where he anointed Kennedy's pale forehead with holy oil in the sign of the cross and spoke the first part of the Lord's Prayer: "Our Father, Who art in heaven, hallowed be Thy name, Thy kingdom come, Thy will be done, on earth as it is in heaven."[37] Like Father Huber's words, Eakins's painting marked Kennedy's passage from one world to the next, that day when it was the altarpiece of a future it could never know.

1 Scott Barker, "Suite 850," *Fort Worth Star-Telegram,* February 4, 2001.

2 William Manchester, *The Death of a President: November 20–November 25, 1963* (New York: Harper and Row, 1967), 120–21.

3 Manchester, *Death of a President,* 87, 112.

4 Most audiences in the 1880s were not ready for Eakins's portrayal of the male nude. The painting met with a "resounding critical silence" when it was displayed in Louisville and Chicago soon after it was finished. The reaction followed the negative and embarrassed reception of the picture in Philadelphia, the artist's home city, where Eakins's patron, the Pennsylvania Academy of the Fine Arts trustee Edward Hornor Coates, chose to buy another of the artist's paintings instead of the one he had commissioned. (The painting Coates selected was *The Pathetic Song* [1881], now in the collection of the Corcoran Gallery of Art in Washington, D.C.) Eakins wrote that his "honors are misunderstanding, persecution and neglect, enhanced because unsought," and indeed *Swimming* was not understood in his own era. It was made for the future, and in the 1960s the decade's sexual revolution would make Eakins's picture up-to-date at last. Sylvan Schendler, in his book on the artist published in 1967, extravagantly praised *Swimming*'s evocation of Walt Whitman and even faulted Eakins for not going further and showing frontal nudity. See Marc Simpson, "*Swimming* through Time: An Introduction," and Doreen Bolger, "'Kindly Relations': Edward Hornor Coates and *Swimming,*" in Doreen Bolger and Sarah Cash, eds., *Thomas Eakins and the Swimming Picture* (Fort Worth, Texas: Amon Carter Museum, 1996), 4, 44; Thomas Eakins, letter to Harrison Morris, April 23, 1894, Charles Bregler's Thomas Eakins Collection, Pennsylvania Academy of the Fine Arts, Philadelphia; Sylvan Schendler, *Eakins* (Boston: Little, Brown, 1967), 81, 86.

5 Sarah Cash, "'Friendly and Unfriendly': The Swimmers of Dove Lake," in Bolger and Cash, eds., *Thomas Eakins,* 49–50. Cash learned about Dove Lake from Elizabeth Johns, who first identified the site.

6 For an account of "the changes wrought by industrialization" in *Swimming*—that is, the painting's depiction of historically specific changes in labor and leisure—see Martin Berger, *Man Made: Thomas Eakins and the Construction of Gilded Age Manhood* (Berkeley: University of California Press, 2000), 92.

7 Robert J. Donovan, *PT 109: John F. Kennedy in World War II* (New York: McGraw-Hill, 1961), 147–52.

8 John Hersey, "Survival," *The New Yorker* (June 17, 1944): 31–43. Robert M. Coates's review, "The Art Galleries: The Eakins Centennial," appears on page 52 of the issue.

9 Margaret Breuning, "New York Views Art of Eakins in Comprehensive Exhibition," *Art Digest* 18 (June 1, 1944), quoted in Bolger and Cash, eds., *Thomas Eakins,* 128; Hersey, "Survival," 32.

10 Whitney Davis, "Erotic Revision in Thomas Eakins's Narratives of Male Nudity," *Art History* 17 (September 1994): 330.

11 Quoted in ibid.

12 Howard Nemerov, "A Day on the Big Branch," in *The Collected Poems of Howard Nemerov* (Chicago: University of Chicago Press, 1977), 150.

13 Marc Simpson, "*Swimming* through Time," 3.

14 James Dickey, "On the Coosawattee," in Dickey, *Helmets* (Middletown, Conn.: Wesleyan University Press, 1964), 18–23; Joyce Carol Oates, "Out of Stone, Into Flesh," in Harold Bloom, ed., *Modern Critical Views: James Dickey* (New York: Chelsea House, 1987), 78. For a compelling account of Dickey's service in the Second World War, see Diederik Oostdijk, *Among the Nightmare Fighters: American Poets of World War II* (Columbia, S.C.: University of South Carolina Press, 2011), 125–36. Dickey's other early 1960s poems of water also evoke the war and the melancholy mood of Eakins's painting. See, for example, "The Lifeguard," where the title figure dives "head down in the cold," looking in vain for a submerged child, and later sees that child, drowned, surfacing on the reflections of the moon, "dilating to break / The surface of stone with his forehead" (Dickey, "The Lifeguard," in *Drowning with Others* [Middletown, Conn.: Wesleyan University Press, 1962], 11–12). Dickey later wrote *Deliverance* (1970), a novel with its own relation to Eakins's painting.

15 Joseph Heller, *Catch-22* (1961; repr. New York: Simon and Schuster, 2004), 337–38.

16 Sarah Burns, *Painting the Dark Side: Art and the Gothic Imagination in Nineteenth-Century America* (Berkeley: University of California Press, 2004), 189. Burns notes that critics in Eakins's era mistook *The Gross Clinic* for a dissection scene, Sadakichi Hartmann, for example, writing of the "light concentrated upon the dissecting table, while the rest of the room is drowned in dismal shadows" (188).

17 For the work's various titles, see Bolger and Cash, eds., *Thomas Eakins,* 123–24.

18 Manchester, *Death of a President,* 121.

19 Bascom N. Timmons, *Garner of Texas: A Personal History* (New York: Harper, 1949), 8.

20 Hersey, "Survival," 34, 31.

21 Arthur Danto, "Men Bathing, 1883: Eakins and Seurat," *Art News* 94 (March 1995): 96; William Homer and John Talbot, "Eakins, Muybridge, and the Motion Picture Process," *Art Quarterly* 26 (summer 1963): 213.

22 For a detailed account of the Zapruder film, see David M. Lubin's fine book *Shooting Kennedy: JFK and the Culture of Images* (Berkeley: University of California Press, 2003).

23 Michael Leja, *Looking Askance: Skepticism and American Art from Eakins to Duchamp* (Berkeley: University of California Press, 2004), 63, 69.

24 Ibid., 259 n.33.

25 "At the Private View. First Impressions of the Autumn Exhibition at the Academy of the Fine Arts," *Philadelphia Times,* October 29, 1885, quoted in Bolger and Cash, eds., *Thomas Eakins,* 124.

26 Davis, "Erotic Revision," 326.

27 Manchester, *Death of a President,* 121.

28 Oliver Larkin, *Art and Life in America,* rev. and enlarged ed. (1949; New York: Holt, Rinehart, and Winston, 1960), 278.

29 Simpson, "*Swimming* through Time," 1; Pollaiuolo's engraving appears on page 131.

30 Lloyd Goodrich, *Thomas Eakins* (Cambridge, Mass.: Harvard University Press, 1982), vol. 1, p. 235.

31 David M. Lubin, "Projecting an Image: The Contested Cultural Identity of Thomas Eakins," *Art Bulletin* 84 (September 2002): 511.

32 Kristin Schwain, *Signs of Grace: Religion and American Art in the Gilded Age* (Ithaca, N.Y.: Cornell University Press, 2008), 13–14.

33 Tom Henry and Laurence Kanter, *Luca Signorelli: The Complete Paintings* (New York: Rizzoli, 2002), 56.

34 Recent technical analysis of Eakins's paintings—for example, the revelation that he projected images onto his canvases with an optical device to aid his realism—has made the art seem all the more forensic. Indeed, the methods of analyzing Eakins's pictures match the artist's own remorseless empiricism. *Swimming,* conserved in 1993 with the aid of the stereomicroscope, x-radiography, and infrared reflectography, came to shine again beneath a scrupulous and scientific focus, its every blemish documented and noted, the artist's method, pace, and sequence of working all revealed. The picture became a historical event, even a crime scene, requiring such detective work to be illuminated. For the account of projected images, see Darrel Sewell et al., *Thomas Eakins,* exh. cat. (Philadelphia: Philadelphia Museum of Art, 2001). For the 1993 conservation, see Claire M. Barry, "*Swimming* by Thomas Eakins: Its Construction, Condition, and Restoration," in Bolger and Cash, eds., *Thomas Eakins,* 98–116. For the connection between art historical connoisseurship and crime solution, see Carlo Ginzburg (with an introduction by Anna Davin), "Morelli, Freud and Sherlock Holmes: Clues and Scientific Method," *History Workshop* 9 (Spring 1980): 5–36.

35 Randall C. Griffin, "Thomas Eakins's Construction of the Male Body, or 'Men Get to Know Each Other across the Space of Time,'" *Oxford Art Journal* 18 (1995): 74.

36 Schendler, *Eakins,* 86.

37 Manchester, *Death of a President,* 216.

Chronology: President John F. Kennedy's Visit to Fort Worth and Dallas, November 21–22, 1963

Nicola Longford

President Kennedy's visit to Texas in November 1963 was a whirlwind trip to help unite the divided Democratic Party as he sought re-election in 1964. The planned five-city visit, with stops in San Antonio, Houston, Fort Worth, Dallas, and Austin (fig. 50), was the first public tour on which the First Lady Jacqueline Kennedy accompanied her husband after the death in August of their infant son, Patrick. Mr. and Mrs. Kennedy were accompanied by Vice President Lyndon B. Johnson and his wife, Lady Bird, and the governor of Texas John Connally and his wife, Nellie. Each stop included a motorcade.

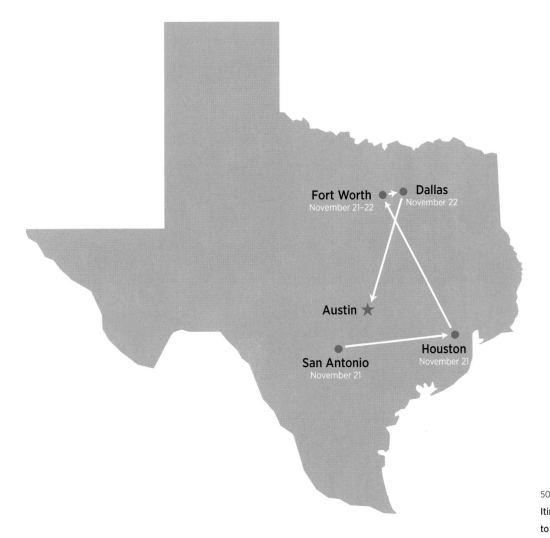

50

Itinerary of the presidential visit
to Texas, November 1963

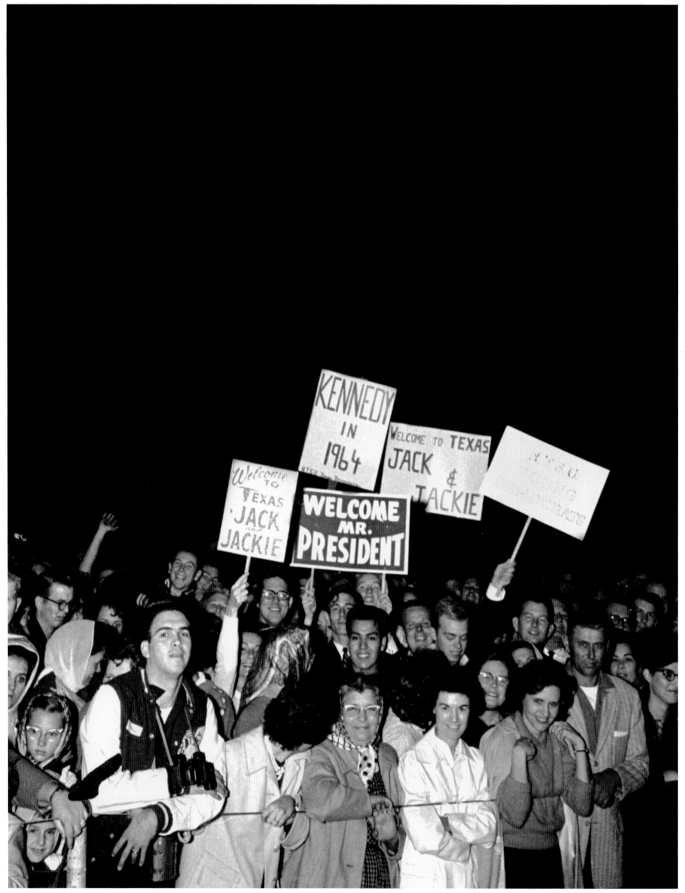

November 21, 1963

Carswell Air Force Base, Fort Worth

Crowds gather to greet President and Mrs. Kennedy. (51) **11:07 p.m.** *Air Force One* lands. **11:15 p.m.** President and Mrs. Kennedy disembark. (52) **11:20 p.m.** Motorcade departs for the Hotel Texas in downtown Fort Worth.

Hotel Texas, Fort Worth

11:50 p.m. President and Mrs. Kennedy arrive at the Hotel Texas and greet crowds inside and outside the hotel. They spend the night in suite 850. (53)

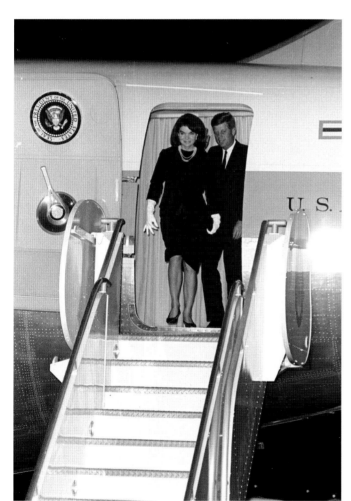

52

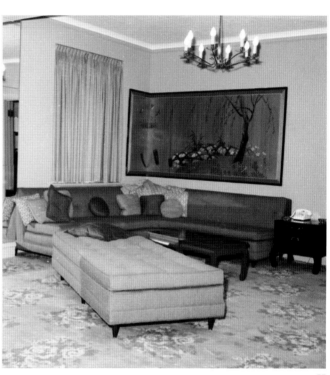

53

November 22, 1963

Hotel Texas, Fort Worth

8:45 a.m. President Kennedy greets crowds in the parking lot outside the Hotel Texas. Mrs. Kennedy remains in suite 850. (54, 55) **8:50 a.m.** The Texas congressman Jim Wright introduces Vice President Lyndon Johnson, who speaks briefly before introducing the president. President Kennedy delivers an impromptu address outside the hotel. (56) **9:00 a.m.** President Kennedy arrives in the ballroom for the Fort Worth Chamber of Commerce breakfast. (57) **9:20 a.m.** On joining the president at

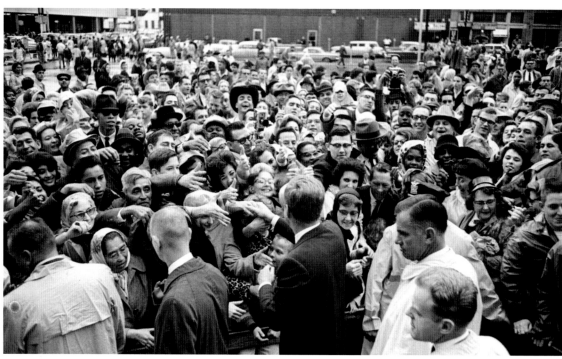

54

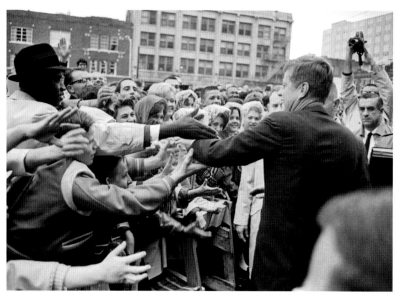

55

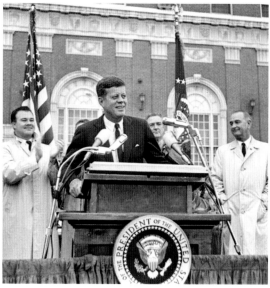

56

breakfast, Mrs. Kennedy receives a standing ovation. **9:25 a.m.** President Kennedy gives what will turn out to be his last public speech. **9:50 a.m.** President and Mrs. Kennedy are presented with gifts of a cowboy hat and boots. (58) **10:15 a.m.** Breakfast concludes; President and Mrs. Kennedy return to suite 850. **10:40 a.m.** Motorcade departs Hotel Texas for Carswell Air Force Base. (59)

Carswell Air Force Base, Fort Worth

11:20 a.m. *Air Force One*, with Mr. and Mrs. Kennedy aboard, departs from Carswell Air Force Base for the short flight to Dallas. *Air Force Two*, with Vice President and Mrs. Johnson aboard, follows.

57

58

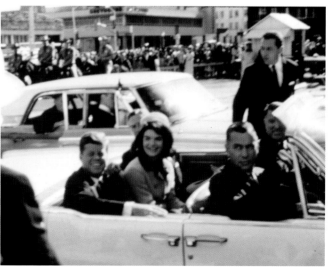

59

Love Field Airport, Dallas

11:36 a.m. *Air Force Two* lands at Love Field. The Johnsons disembark to greet the Kennedys upon their arrival. (60) **11:38 a.m.** *Air Force One* lands. (61) **11:44 a.m.** President and Mrs. Kennedy and Governor and Mrs. Connally disembark from *Air Force One* and are greeted by the Johnsons and Dallas officials. (62) **11:46 a.m.** President and Mrs. Kennedy bypass scheduled plans and approach the welcoming crowds at the fence line. (63) **11:52 a.m.** Motorcade departs Love Field Airport, headed for a luncheon at the Dallas Trade Mart. (64)

61

60

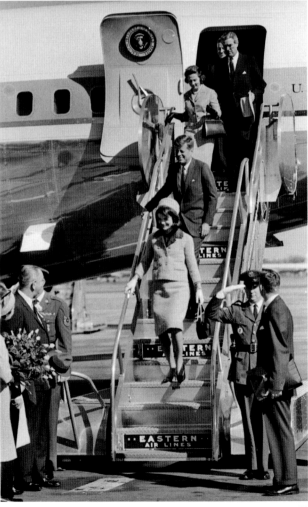

62

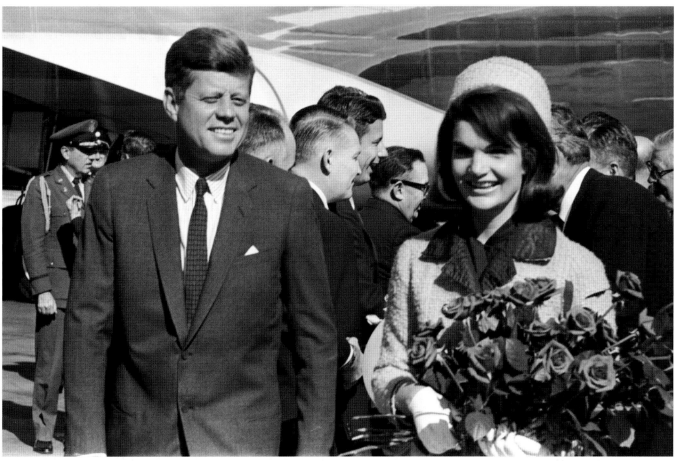

63

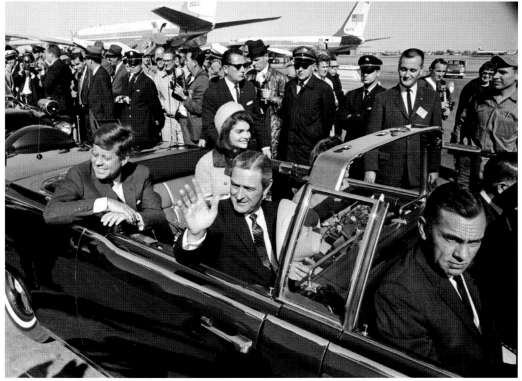

64

Motorcade Route, Dallas

12:21 p.m. The presidential limousine turns off Harwood Street and onto Main Street in downtown Dallas. (65) **12:27 p.m.** Large crowds line Main Street in downtown Dallas near the Adolphus Hotel. (66) **12:30 p.m.** President Kennedy is assassinated and Governor Connally wounded in Dealey Plaza. (67) **12:31 p.m.** The presidential limousine races up Stemmons Freeway to Parkland Memorial Hospital. (68)

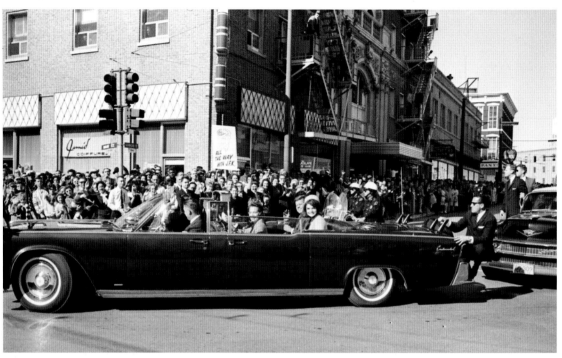

65

66

Parkland Memorial Hospital, Dallas

12:34 p.m. The first announcement of the shooting goes out on the United Press International wire service. **12:36 p.m.** The presidential limousine arrives at Parkland Hospital. **1:00 p.m.** Doctors pronounce President Kennedy dead; a crowd gathers outside the hospital awaiting news. (69)

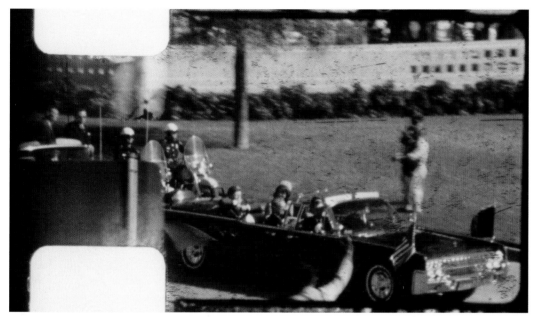

67

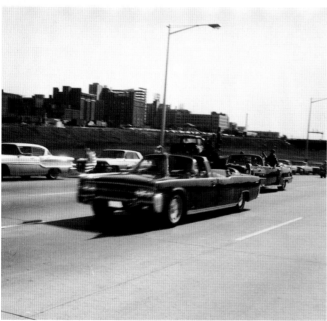

68

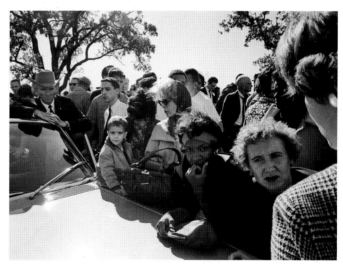

69

Parkland Memorial Hospital, Dallas

1:26 p.m. Vice President Johnson departs for Love Field Airport to return to Washington, D.C. (70) **1:30 p.m.** The White House Assistant Press Secretary Malcolm Kilduff announces to the press that President Kennedy is dead. (71)

Love Field Airport, Dallas

1:33 p.m. Vice President Johnson boards *Air Force One* at Love Field. **2:08 p.m.** President Kennedy's body, accompanied by Mrs. Kennedy, is carried by hearse from Parkland Hospital to Love Field Airport. (72) **2:20 p.m.** The hearse arrives at Love Field, and President Kennedy's casket is loaded onto *Air Force One* by Secret Service agents. (73) **2:38 p.m.** Lyndon B. Johnson takes the oath of office aboard *Air Force One*. (74) **2:47 p.m.** *Air Force One* departs for Andrews Air Force Base, Maryland.

70

71

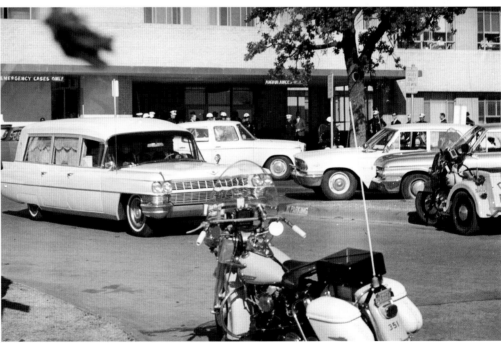

72

A stunned nation received the news of the death of President John F. Kennedy in Dallas, Texas. Suspense and uncertainty took hold as the world questioned the surreal and unimaginable events that were taking place in the days after the assassination—not only had the president of the United States been assassinated, but also Lee Harvey Oswald, the alleged assassin, was himself murdered two days later by Jack Ruby in the Dallas Police Headquarters—events that fueled global speculation and fear about who else might be involved and why.

The day after the assassination, in an attempt to console a grieving nation, President Lyndon B. Johnson declared November 25, the day of President Kennedy's state funeral and burial at Arlington National Cemetery, a national day of mourning. On the same day, Lee Harvey Oswald was buried in Fort Worth.

On November 29, President Johnson formed the President's Commission on the Assassination of President Kennedy, later known as the Warren Commission, named after the Supreme Court Justice Earl Warren. The results were released in the fall of 1964. Subsequent official and unofficial investigations have been carried out, yet speculation continues about who was involved, why, and how. In the ensuing decades, the powerful memory of a young president who inspired hope and community service to younger generations has lived on.

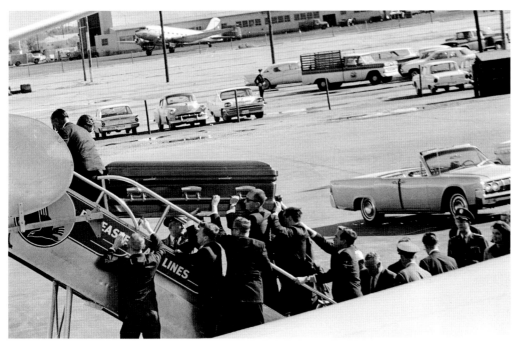

73

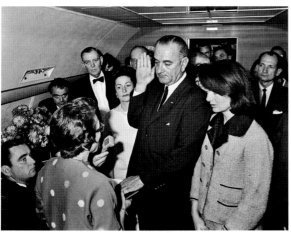

74

Checklist of the Exhibition

Cat. 1

Claude Monet (French, 1840–1926)

Portrait of the Artist's Granddaughter (Portrait de Germaine Hoschedé avec sa poupée), c. 1876–77

Oil on canvas

31⅞ × 23⅝ inches

Location unknown
Owner in 1963: Collection of Mr. and Mrs. J. Lee Johnson III
Not in the exhibition

Cat. 2

Pablo Picasso (Spanish, 1881–1973)

Angry Owl, 1951–53

Bronze, edition of 6

12¾ × 12¼ × 12⅝ inches

Collection of Gwendolyn Weiner
Owner in 1963: Ted Weiner

Cat. 3

Lyonel Feininger (German, active in America, 1871–1956)

Manhattan II, 1940

Oil on canvas

38⅛ × 28⅝ inches

Collection of the Modern Art Museum of Fort Worth, Texas; anonymous gift. 1946.06.G.P.
Owner in 1963: Fort Worth Art Association, Fort Worth, Texas

Cat. 4

Morris Graves (American, 1910–2001)

Spirit Bird, c. 1956

Tempera on paper

11¾ × 17½ inches

Collection of the Modern Art Museum of Fort Worth, Texas, gift of the William E. Scott Foundation. 1963.07.03.G.P.
Owner in 1963: Fort Worth Art Association, Fort Worth, Texas, gift of the William E. Scott Foundation

Cat. 5

Franz Kline (American, 1910–1962)

Study for Accent Grave, 1954

Oil wash on paper

14 × 9¾ inches

Extended loan to the Palm Springs Art Museum, California, from the collection of Gwendolyn Weiner. L1980-4.10
Owner in 1963: Ted Weiner

Cat. 6

Jack Zajac (American, b. 1929)

Small Bound Goat, 1962

Bronze, number 1 of an edition of 6

8 × 6⅞ × 11 inches

Amon Carter Museum of American Art, Fort Worth, Texas, gift of Ruth Carter Stevenson. 1999.16
Owner in 1963: Collection of Mr. and Mrs. J. Lee Johnson, as *Sacrificial Goat*

Cat. 7

Henry Moore (English, 1898–1986)

Three Points, 1939–40

Bronze, edition of 10

5 ½ × 7 ½ × 3 ⅞ inches

Extended loan to the Palm Springs Art Museum, California, from
the collection of Gwendolyn Weiner. L2007-15.3
Owner in 1963: Ted Weiner

Cat. 8

Eros Pellini (Italian, 1909–1993)

A Girl from Lombardia, 1958–59

Bronze

16 × 7 × 7 inches

Extended loan to the Palm Springs Art Museum, California, from
the collection of Gwendolyn Weiner. L1980-3.25
Owner in 1963: Ted Weiner

Cat. 9

John Marin (American, 1872–1953)

Sea and Rock, Stonington, Maine, 1919

Watercolor on paper

9 ½ × 12 ⅛ inches

Location unknown
Owner in 1963: Collection of Mr. and Mrs. Sam Cantey III
Not in the exhibition

Cat. 10

Maurice Brazil Prendergast (American, 1858–1924)

Summer Day in the Park, 1918–23

Oil on canvas

25 ¾ × 26 ¾ inches

Private collection, Fort Worth
Owner in 1963: Collection of William Marshall Fuller

Cat. 11

Vincent van Gogh (Dutch, 1853–1890)

*Road with Peasant Shouldering a Spade (Route aux confins de
Paris, avec paysan portant la bêche sur l'épaule),* 1887

Oil on canvas

18 ½ × 28 ¼ inches

Private collection
Owner in 1963: Ruth Carter Johnson

Cat. 12

John Henry Twachtman (American, 1853–1902)

Geyser Pool, Yellowstone, c. 1890–93

Oil on canvas

30 × 24 ⅞ inches

Private collection, Fort Worth
Owner in 1963: Collection of Mr. and Mrs. William M. Fuller

Cat. 13

Charles Marion Russell (American, 1864–1926)

Lost in a Snowstorm—We Are Friends, 1888

Oil on canvas

24 × 43 ⅛ inches

Amon Carter Museum of American Art, Fort Worth, Texas. 1961.144
Owner in 1963: Amon Carter Museum of Western Art, Fort Worth,
Texas, as *Meeting in a Blizzard*

Cat. 14

Marsden Hartley (American, 1877–1943)

Sombrero with Gloves, 1936

Oil on canvas

20 ½ × 28 inches

Collection of Katherine Elizabeth Albritton
Owner in 1963: Amon Carter Museum of Western Art,
Fort Worth, Texas

Cat. 15

Thomas Eakins (American, 1844–1916)

Swimming, 1885

Oil on canvas

27⅜ × 36⅜ inches

Amon Carter Museum of American Art, Fort Worth, Texas,
purchased by the Friends of Art, Fort Worth Art Association, 1925;
acquired by the Amon Carter Museum, 1990, from the Modern
Art Museum of Fort Worth through grants and donations from the
Amon G. Carter Foundation, the Sid W. Richardson Foundation, the
Anne Burnett and Charles Tandy Foundation, Capital Cities/ABC
Foundation, Fort Worth *Star-Telegram*, The R. D. and Joan Dale
Hubbard Foundation and the people of Fort Worth. 1990.19.1
Owner in 1963: Fort Worth Art Association, Fort Worth, Texas, as
Swimming Hole

Raoul Dufy (French, 1877–1953)

Bassin de Deauville, 1938

Oil on canvas

Private collection
Owner in 1963: Perry Bass family
Not pictured and not in the exhibition

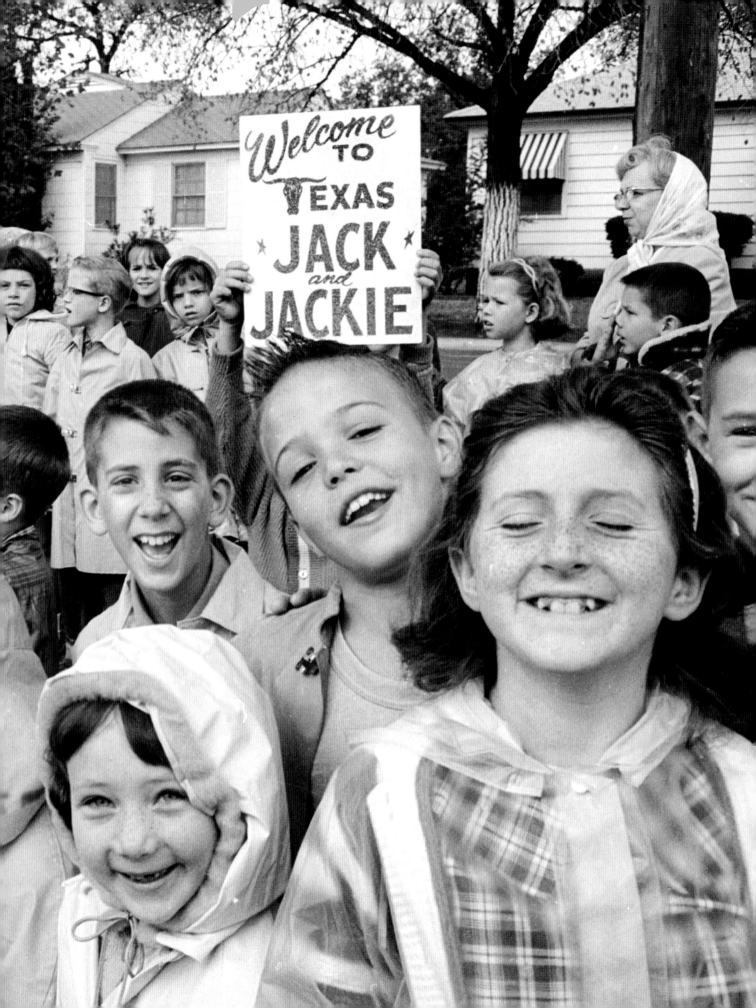

Index

Notes: Illustrations are denoted by page references in italics. To distinguish them from works of art, publications are annotated with the date of publication.

Photography and Copyright Credits

Hotel Texas: An Art Exhibition for the President and Mrs. John F. Kennedy is organized by the Dallas Museum of Art in association with the Amon Carter Museum of American Art.

Citi Private Bank is the presenting sponsor of the exhibition in Dallas.

Private Bank

Air transportation is provided by American Airlines.

The exhibition in Fort Worth is supported by a generous contribution from Shirlee J. and Taylor Gandy, in memory of Ruth Carter Stevenson.

Exhibition Schedule

Dallas Museum of Art
1717 North Harwood Street, Dallas, Texas
May 26–September 15, 2013

Amon Carter Museum of American Art
3501 Camp Bowie Boulevard,
Fort Worth, Texas
October 12, 2013–January 12, 2014

Published by the Dallas Museum of Art
in association with the Amon Carter
Museum of American Art

Distributed by Yale University Press,
New Haven and London
P.O. Box 209040
302 Temple Street
New Haven, CT 06520-9040
www.yalebooks.com/art

Dallas Museum of Art

Maxwell L. Anderson, The Eugene McDermott Director

Olivier Meslay, Associate Director of Curatorial Affairs, Senior Curator of European and American Art, and The Barbara Thomas Lemmon Curator of European Art

Tamara Wootton-Bonner, Associate Director of Collections and Exhibitions

Eric Zeidler, Publications Manager

Giselle Castro-Brightenburg, Imaging Manager

Martha MacLeod, Curatorial Administrative Assistant

Amon Carter Museum of American Art

Andrew J. Walker, Director

Will Gillham, Director of Publications

Stefanie Ball Piwetz, Publications Manager

Edited and indexed by Frances Bowles
Proofread by Sharon Vonasch

Designed and produced by Glue + Paper Workshop LLC, Chicago
www.glueandpaper.com

Color separations by Embassy Graphics, Winnipeg, Canada

Printed and bound in China by Asia Pacific Offset

Library of Congress Cataloging-in-Publication Data

Hotel Texas : An Art Exhibition for the President and Mrs. John F. Kennedy / essays by Olivier Meslay, Scott Grant Barker, David M. Lubin, Alexander Nemerov ; chronology by Nicola Longford.
 pages cm
 Issued in connection with an exhibition organized by the Dallas Museum of Art and presented in association with the Amon Carter Museum of American Art, Fort Worth.
 Includes bibliographical references and index.
 Summary: "The events associated with John F. Kennedy's death are etched into our nation's memory. This fascinating book tells a less familiar part of the story, about a special art exhibition organized by a group of Fort Worth citizens. On November 21, 1963, the Kennedys arrived in Fort Worth around midnight, making their way to Suite 850 of the Hotel Texas. There, installed in their honor, was an intimate exhibition that included works by Monet, Van Gogh, Marin, Eakins, Feininger, and Picasso. Due to the late hour, it was not until the following morning that the couple viewed the exhibition and phoned one of the principal organizers, Ruth Carter Johnson, to offer thanks. Mrs. Kennedy indicated that she wished she could stay longer to admire the beautiful works. The couple was due to depart for Dallas, and the rest is history. This volume reunites the works in this exhibition for the first time and features some previously unpublished images of the hotel room. Essays examine this exhibition from several angles: anecdotal, analytical, cultural, and historical, and include discussions of what the local citizens wished to convey to their distinguished viewers"— Provided by publisher.
 ISBN 978-0-300-18756-4 (hardback)
 1. Art Exhibition for President and Mrs. John F. Kennedy (Fort Worth, Tex.) 2. Art, Modern—Exhibitions. 3. Art—Collectors and collecting—Texas—Fort Worth. 4. Kennedy, John F. (John Fitzgerald),

1917–1963—Travel—Texas—Fort Worth. 5. Onassis, Jacqueline Kennedy, 1929–1994—Travel—Texas—Fort Worth. I. Meslay, Olivier. II. Barker, Scott Grant. III. Lubin, David M. IV. Nemerov, Alexander. V. Longford, Nicola. VI. Dallas Museum of Art. VII. Amon Carter Museum of American Art.
 N6448.A78H68 2013
 709.04'00747642812—dc23
 2012043680

Front cover: Crowd greeting John F. Kennedy in Fort Worth, November 22, 1963 (detail of fig. 5)

Front cover and spine: Installation of artworks in the Hotel Texas, November 21–22, 1963

Back cover: President and Mrs. John F. Kennedy at Love Field, Dallas, November 22, 1963 (detail of fig. 6)

Endsheets: Map of Dallas and Fort Worth, Humble Oil Company, 1962

Page 3: John F. Kennedy standing in a convertible automobile outside the Hotel Texas, Fort Worth, November 22, 1963

Page 9: Ruth Carter Johnson and Lucile Weiner with *Angry Owl* by Pablo Picasso, November 21, 1963

Page 13: Welcoming crowd greeting John F. Kennedy on his arrival in Dallas, November 22, 1963

Page 108: Schoolchildren watching the presidential motorcade leave Fort Worth on the way to Carswell Air Force Base, November 22, 1963